PRINT'S BEST **TYPOGRAPHY** PROMOTIONS

PRINT'S BEST TYPOGRAPHY

Library of Congress Catalog Card Number 92-062285
ISBN 0-915734-81-8

RC PUBLICATIONS

President and Publisher: Howard Cadel
Vice President and Editor: Martin Fox
Creative Director: Andrew Kner
Managing Director, Book Projects: Linda Silver
Administrative Assistant: Nancy Silver
Assistant Art Director: Nicole Haniph
Introduction by: Philip B. Meggs

The staff of Print's Best
Typography wishes to
acknowledge the
contribution of Philip B.
Meggs, who as special
consultant played a major
role in selecting the material
for this book. A graphic
designer and design
educator, Meggs teaches at
Virginia Commonwealth
University in Richmond. He is
author of A History of Graphic
Design (now in its second
edition), published by Van
Nostrand Reinhold, as well as
Type & Image, also published
by Van Nostrand Reinhold.
He is a contributing editor of
PRINT magazine.

Print's Best
TYPOGRAPHY

WINNING DESIGNS FROM PRINT MAGAZINE'S NATIONAL COMPETITION

Edited by
LINDA SILVER

Designed by
ANDREW KNER

Published by
RC PUBLICATIONS, INC.
NEW YORK, NY

"I bring into the light of day the precious stores of knowledge and wisdom long hidden in the grave of ignorance. I am the leaden army that conquers the world; I am type!" proclaimed a 1933 broadside designed and written by the great typeface designer Frederic Goudy. Were he alive today, Goudy would probably be alarmed at the turn American type design has taken a half century after his death: His army of lead soldiers has been transformed into a fusillade of electronic bits, bytes, and pixels. As the work reproduced in this book stunningly demonstrates, today's computer-based technology permits designers to extend the visual range of type into new directions that Goudy could hardly have foreseen.

Typography is no longer just a craft used to give visual form to the spoken language, for contemporary graphic designers have reconstituted type into symbolic icons and expressive visual forms undreamed of by Goudy and his contemporaries. A number of significant changes in our modern-day culture have caused this revolution in the noble art of alphabets. In earlier times, the spoken word was ephemeral but the printed word remain fixed on carved stone or printed page. Electronic technology now makes possible the recording of speech, permitting the spoken word to survive just as the printed word does. Typography has thus been freed from a mindset that viewed it as the sole documentary record of human thought.

The kinetics of film, video, and animation have greatly influenced print graphics, resulting in a new emphasis on movement and energy. The ability of type literally to march across the video screen, zoom back into infinity, or rush forward until the dot of a lowercase *i* fills the screen has not been lost on graphic designers working with a static printed page. Capturing the vitality of kinetic energy and freezing it in printing inks is now a commonplace.

Visual art has been redefined, and 20th-century artists and designers have proven that colors, textures, and shapes—including letterforms—have lives of their own apart from their representational or symbolic meaning. In typographic design, this nonverbal level of expression can be teamed with the verbal meaning of words to intensify and enhance the message.

For over 500 years, type marched in horizontal rows dictated by the relentless constraints of typesetting technology. Today, flexibility abounds. Technology places unprecedented control of space and scale in the hands of the

CONTENTS

designer. Both enormously large and minutely small sizes of type operate at extremes of scale that disregard the limitations of traditional technology. Spatial configurations warp, bend, fracture, and separate, defying the regimen of Goudy's leaden army. Type can run over, around, and through images with any desired degree of transparency. All of these new possibilities can be accomplished with the click of a mouse. Tracking of letterspacing in increments of 1/20,000th of an em, using negative line spacing, stretching type, bending it back into space, and setting type in circles, ovals, and any configuration devised by the designer's imagination become routine.

Technology alone cannot fully explain the creative freedom of contemporary graphic design. Art moves forward by action and reaction, and many designers seem to be challenging the ease and conformity permitted by computer technology. Some are experimenting with spontaneous—and even crude—yet beautifully designed hand lettering and writing. Collage is used to combine unlike and expected shapes, color, and texture. Many designers are fabricating words as solid dimensional objects, capable of being constructed from substances ranging from Plexiglas to cake icing or discarded pieces of wire or metal; anything that can make an image becomes a potential tool for the designer seeking to imbue words with expressive form.

An element of play has entered typographic design, pushing at the seams of conventional wisdom and traditional practice. Designers sometimes propel their work toward the outer limits of legibility, almost as if they are daring the client to reject it or defying the reader to decipher it. Although failures abound, many of the works included here prove that risk-taking can avert disaster and result in graphic design which fascinates the eye with new visions and experiences.

Each of the 175 designs selected for this book appeared in the 1992 edition of PRINT's Regional Design Annual. They are presented much larger and in a more detailed form than is possible in the Annual, and in a context that emphasizes their typographic distinction. The work ranges over the entire spectrum of print communications, and if Goudy were here to review it, he would doubtless amend his broadside to read: "I am the liberated letters that bring into the light of day the precious duality of form and message, freed from the grave of tradition and rigid technology. I am the electronic army that flows around the global village; I am type!"—*Philip B. Meggs*

Cover (1) and inside pages (5-8) from 1991 Phoenix Addy Awards call-for-entries booklet. Award certificates (2-4).

DESIGN FIRM: P.S. Studios, Phoenix, Arizona

DESIGNERS: Peter Shikany, Judy Smith, Margaret Beatty

COPYWRITER: Joanne Bell-Smith

TYPOGRAPHY: Andresen Typographics

Listen, I don't wanna be a whiner but nobody here really appreciates me or has the slightest idea how creative I could be if they'd just keep their blundering meathooks to themselves and stop trashing my stuff and now I've got this *1991 Addy Call for Entries* in front of me and all I can think is how good it would feel to win but let's face it, 1991 was a sorry year and frankly a big dud for me since I don't have any decent work to show, even though the cleaning lady seemed to like that piece I did a while back and maybe I should stop being so modest and seriously think about entering it and maybe a few more pieces, too, I mean they might be better than I'm giving myself credit for, they might actually win and jeez, if I won, it would be complete vindication, NAH-nah-nah-NAH-nah nirvana, it would be just like in my dreams, people would leap up to give me a standing ovation and crowd around me to pump my hand, they'd fight to woo me away, everybody would be smarmy and coveting, and all that would be just fine, it would be terrific, if I won all my clients would personally thank me for working on their accounts, all my co-workers would throw me a gala victory party, all my ex-lovers would rue the day they left me and it's a sure bet if I won I would get more respect, more recognition, more money, yeah maybe a bonus, and maybe even a bonus on top of a salary raise, maybe even a huge Christmas bonus on top of that because nobody's more talented than me me me me

2.

3.

4.

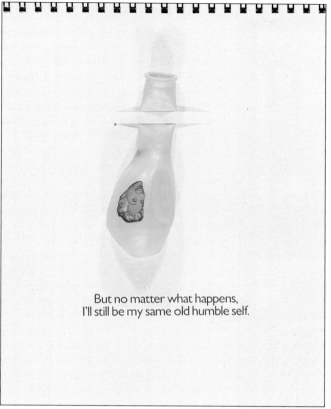

But no matter what happens,
I'll still be my same old humble self.

Especially if I don't win.

reclassify any entry if they feel it's to the entrant's advantage, or if the entry has been placed in the wrong category. The PAC Awards committee reserves the right of final authority on any questionable matters. If you have any questions, call Twila Hopkins, Executive Director, 990-0440. **PRINT** All print and publication entries must be mounted on medium gray board with a 2" margin on all four sides. Attach the entry form to the top right-hand side of the back of each entry. Send campaign entries taped together, accordion style. If you're entering the same piece in more than one category, you must send one copy properly identified with entry form for each category you enter. You may send "stand-up" or specialty items or an 8" x 10" photo of the item. **BROADCAST** Video entries should be submitted on ¾" umatic cassette. Slate each spot with its title and entry category, as well as its length. Audio entries must be submitted on cassette, per category entered. You may submit all entries in the same category on one tape, but not more than one category per tape or all entries on the tape will be disqualified. **PHOTOGRAPHS, ARTWORK, FILM/TAPE FOOTAGE** Entries must be accompanied by finished ad, commercial or printed piece to show how it was used, and must have been used for commercial purposes. **ENTRY FEES** **SINGLE ENTRIES:** Ad Club Members **$30** Others **$35** **CAMPAIGNS:** Ad Club Members **$35** Others **$40** Please attach a photocopy of each entry form to your check. Deliver entry fees to: Davis Ball & Columbatto, 3030 North 3rd Street, Suite 910, Phoenix, AZ 85012. Remember, the deadline is 5pm Thursday, December 5th. Make your check payable to: Phoenix Advertising Club. Entries will be available for pick-up Monday, January 20. No entries will be released before January 20. All entries not claimed by February 15, 1992 will be destroyed. **AWARDS** Winners will be notified by mail. **SHOW LOCATION** Red Lions La Posada, Saturday, January 18 at 6:30pm. **1. RADIO** **A.** Commercial, :30 seconds or less. ▶ **B.** Commercial, :60 seconds. ▶ **C.** Campaign, 3 or more commercials, any length. **2. TELEVISION** **A.** Single commercial, any length, with a production budget under $5,000. ▶ **B.** Campaign, 3 or more commercials, any length, with a production budget under $5,000 per commercial. ▶ **C.** Single commercial, any length, with a production budget over

1991 PHOENIX ADDY AWARDS ▶ YOU ARE CORDIALLY INVITED TO ENTER THE 1991 PHOENIX ADDY AWARDS, TO BE HELD SATURDAY, JANUARY 18 IN THE GRAND BALLROOM OF RED LIONS LA POSADA RESORT. ▶ PLEASE BRING YOUR HEAD WITH YOU, SO THAT FATE MAY WHIMSICALLY TOY WITH ITS DIMENSIONS. ▶ JUST BE SURE TO DIG OUT YOUR BEST WORK AND SEND IN YOUR ENTRIES NO LATER THAN 5 P.M., THURSDAY, DECEMBER 5TH. ▶ WIN OR LOSE, YOU'LL ENJOY A GALA TENSION-FILLED EVENING BLOWN OUT OF ALL PROPORTION, WHICH IS EXACTLY WHAT MAKES THESE AFFAIRS SO COMPELLING. ▶ WE HOPE TO SEE YOU THERE. AND WHAT HAPPENS TO THAT THING ON TOP OF YOUR NECK IS ENTIRELY YOUR OWN BUSINESS. **THE RULES** The PAC Awards Committee reserves the right to pull from the competition, without notice or refund, any print or electronic entries that do not comply with the rules. So, please pay attention. Any type of advertising that appeared between October 13, 1990 and November 30, 1991 is eligible. Any type of design, sales promotion, brochures, commercial art, photography or direct mail that was produced between October 13, 1990 and November 30, 1991 is eligible. Work that has been entered before is not eligible. Entries must be of original creation, with limited use of syndicated materials. Public service advertising, paid or otherwise can only be submitted in the Public Service category. Winners may be asked to submit proof that the work was produced or run during the time period for the show. Ads should not be larger or smaller than they were when they appeared. **ENTRIES MAY BE SUBMITTED BY ANY INDIVIDUAL ADVERTISER, AGENCY, DESIGN FIRM, PRODUCTION COMPANY, OR ANY OTHER ORGANIZATION IN THE PHOENIX METROPOLITAN AREA THAT IS INVOLVED IN CREATING OR PLACING ADVERTISING.** Advertising not created or produced by a Phoenix firm is also eligible if the client is located in Phoenix and if the advertising was designed specifically to run in the Phoenix area. You don't have to be a member of the Phoenix Advertising Club to enter. The judges reserve the right to

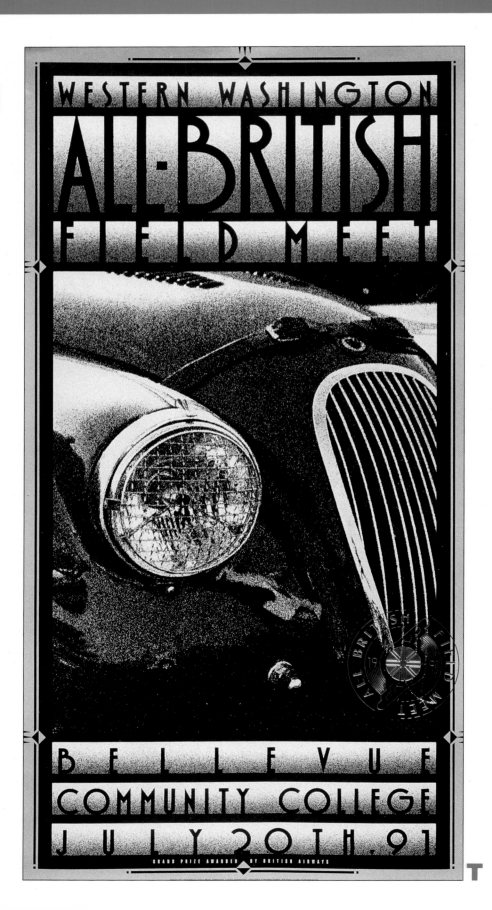

Poster promoting an exhibition of British cars in Western Washington.
DESIGN FIRM: Hornall Anderson Design Works, Seattle, Washington
ART DIRECTOR: Jack Anderson
DESIGNERS: Jack Anderson, David Bates

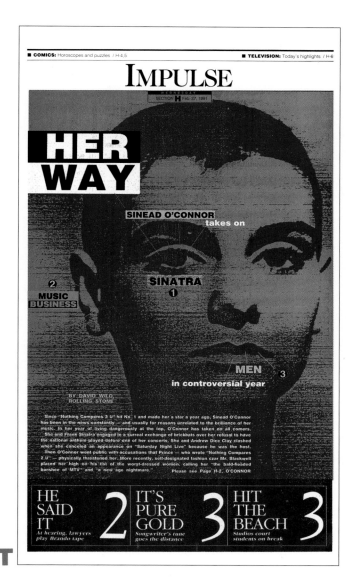

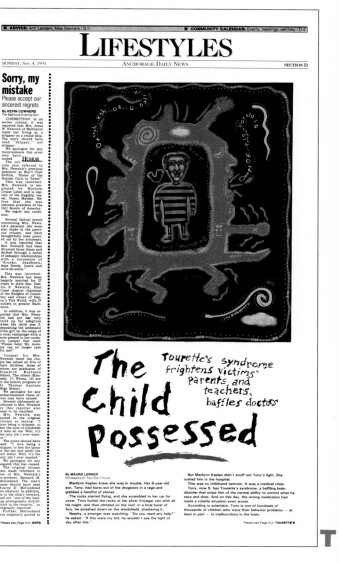

Section pages.

ART DIRECTOR: Galie
Jean-Louis/Anchorage Daily
News, Anchorage, Alaska

DESIGNERS: Galie
Jean-Louis (Her Way), Pete
Spino (Child Possessed)
ILLUSTRATOR: Joel
Nakamura (Child
Possessed)

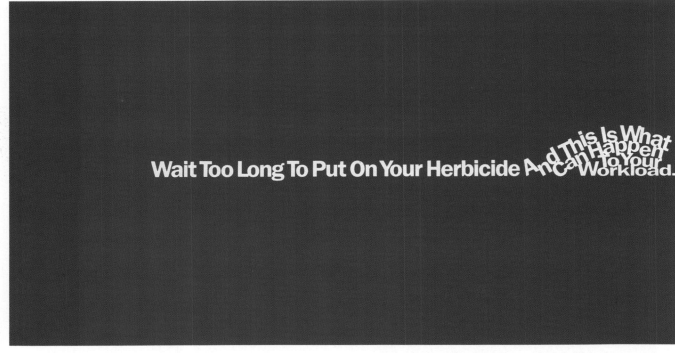

Wait Too Long To Put On Your Herbicide And This Is What Can Happen To Your Workload.

Does it seem like there's too much work and too little time to do it every spring? Switch to Dual. Applied up to thirty days before planting, Dual frees you up to do other things later on, and helps you get a jump on weeds.

Apply Dual early and you'll save on the rising cost of incorporation because the early spring rains will incorporate Dual naturally. You'll also save time at planting, because you won't have to stop to put on your herbicide.

Dual needs only a small amount of rain to activate, and it's highly soluble so it washes off trash easier than other leading herbicides. It provides excellent control of common and problem grasses all season long.

Put the Dual Early Advantage to work on your farm, and you'll get a jump on weeds, and keep your workload from piling up this spring. **The Dual Early Advantage**

CIBA–GEIGY © 1990 CIBA-GEIGY Agricultural Division, P.O. Box 18300, Greensboro, NC 27419. Always read and follow label directions.

Ad for a herbicide.

AGENCY: Martin/Williams, Inc., Minneapolis, Minnesota

ART DIRECTOR: Wendy Hansen

COPYWRITER: Tom Leydon

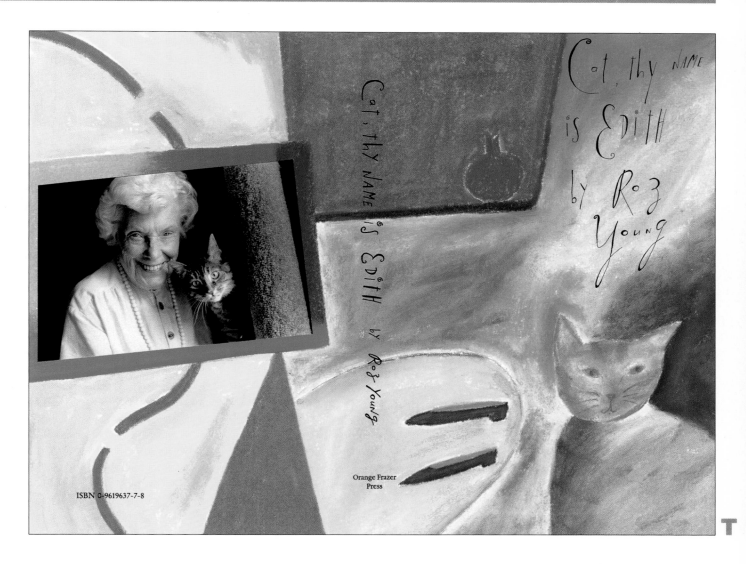

Book jacket.

ART DIRECTOR:

John Baskin

HAND LETTERER/

ILLUSTRATOR:

Linda Scharf, Boston,

Massachusetts

PUBLISHER: Marcy Hawley

AUTHOR'S PORTRAIT:

Michael Wilson

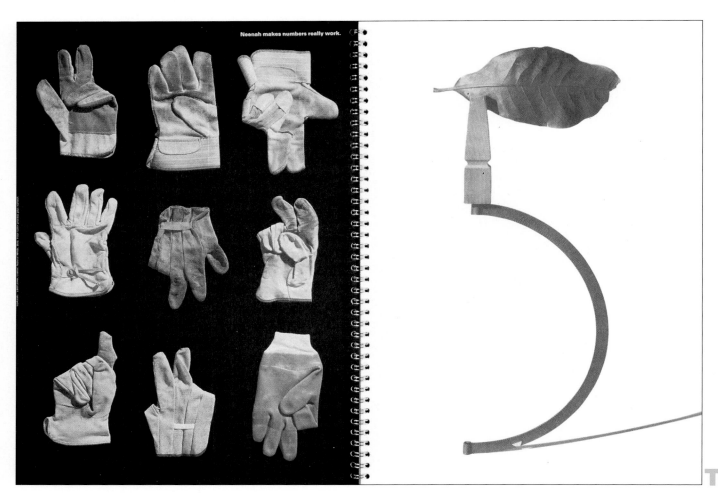

Neenah makes numbers really work.

Spreads from annual report promotional booklet, "Even a Bad Year Looks Great."
DESIGN FIRM: Michael Glass Design, Inc., Chicago, Illinois

ART DIRECTORS/ DESIGNERS: Michael Glass, Kerry Grady
COPYWRITER: Todd Lief
PHOTOGRAPHER: Geof Kern
DESIGN ASSISTANTS: Wesley Rittenberry, Jason Pickleman

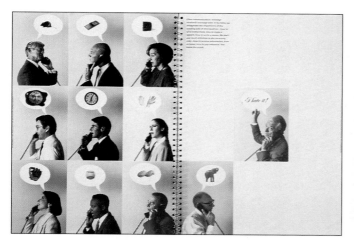

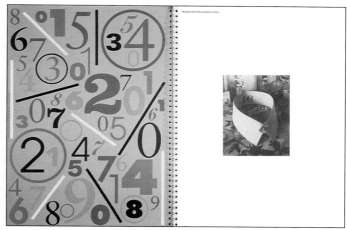

Ad appearing in the
program for Celebration
1991, a cultural event in
Virginia Beach, Virginia.
AGENCY: Barker Campbell
& Farley, Virginia Beach,
Virginia
ART DIRECTOR/
TYPOGRAPHER: Jay Giesen
COPYWRITER: Bill Campbell
TYPESETTING: Tamara
Potter

MARVELOUS. AWESOME.
EXCEPTIONAL. PEERLESS.
KILLER. INCOMPARABLE.
INCREDIBLE. EXCELLENT.
SPECTACULAR. HEROIC.
PRE-EMINENT. SUPERB.
WONDERFUL. SPLENDID.
BOFFO. ACE. FIRST-RATE.
GREATEST. STUPENDOUS.
UNPARALLELED. DIVINE.
SUPERIOR. TOP-DRAWER.
DISTINGUISHED. A-OKAY.
FABULOUS. TOTALLY RAD.

For once, words fail us.
Barker Campbell & Farley salutes Celebration 1991.

14

Shopping bag used as a

promotion at trade shows.

DESIGN FIRM: Copeland

Design, Inc., Atlanta,

Georgia

ART DIRECTOR: Brad

Copeland

DESIGNER: Kevin Irby

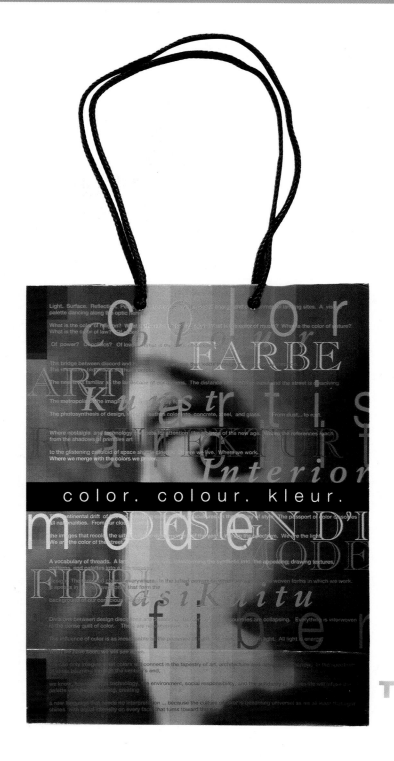

Cover and inside spreads

from Aetna Public Service

1990 annual report.

ART DIRECTOR/

DESIGNER: Lance

Matusek/Aetna, Hartford.

Connecticut

ILLUSTRATOR:

Mary Lempe

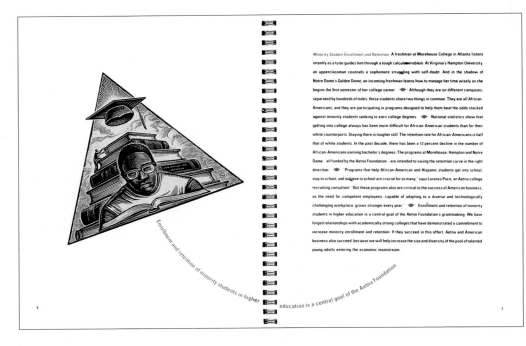

Minority Student Enrollment and Retention A freshman at Morehouse College in Atlanta listens intently as a tutor guides him through a tough calculus problem. At Virginia's Hampton University, an upperclassman counsels a sophomore struggling with self-doubt. And in the shadow of Notre Dame's Golden Dome, an incoming freshman learns how to manage her time wisely as she begins the first semester of her college career. Although they are on different campuses, separated by hundreds of miles, these students share two things in common. They are all African-Americans, and they are participating in programs designed to help them beat the odds stacked against minority students seeking to earn college degrees. National statistics show that getting into college always has been more difficult for African-American students than for their white counterparts. Staying there is tougher still. The retention rate for African-Americans is half that of white students. In the past decade, there has been a 12 percent decline in the number of African-Americans earning bachelor's degrees. The programs at Morehouse, Hampton and Notre Dame - all funded by the Aetna Foundation - are intended to swing the retention curve in the right direction. "Programs that help African-American and Hispanic students get into school, stay in school, and achieve in school are crucial for so many," says Lorenzo Pace, an Aetna college recruiting consultant. "But these programs also are critical to the success of American business, as the need for competent employees, capable of adapting to a diverse and technologically challenging workplace, grows stronger every year." Enrollment and retention of minority students in higher education is a central goal of the Aetna Foundation's grantmaking. We have forged relationships with academically strong colleges that have demonstrated a commitment to increase minority enrollment and retention. If they succeed in this effort, Aetna and American business also succeed, because we will help increase the size and diversity of the pool of talented young adults entering the economic mainstream.

Enrollment and retention of minority students in higher education is a central goal of the Aetna Foundation.

Community Development and Employee Involvement Insurance offers many interesting career experiences, but Aetna employees in Atlanta didn't realize carpentry was one of them. That was before they started swinging hammers to help build homes for the Habitat for Humanity program. Two "Aetna Houses" in Atlanta's Habitat development were sold to families of limited economic means, with financing provided by no-interest loans. An Aetna Foundation FOCUS grant funded the purchase of building materials, and Aetna employees and agents volunteered their time and labor to assist professional tradesmen and the buyers in constructing the houses. Habitat for Humanity is a non-profit, international organization dedicated to finding solutions to the problem of inadequate housing. Its major purpose is to build homes for people who live in substandard housing and who cannot improve their situations through conventional means. The Habitat program is in line with Aetna's priority to form partnerships with groups working to provide decent, affordable housing for people who otherwise could never afford their own homes. Habitat believes in providing capital, not charity, and enlisting co-workers instead of caseworkers. "On a Saturday morning, we started with a vacant building lot and a concrete subfloor. Six weekends later we presented the keys to a new home to a family," says Don McCarthy, general manager for commercial insurance in Atlanta. "This project really brought to life how Foundation support and volunteerism on the part of our employees and agents can result in tangible benefit for deserving people, in this case, our house family." Aetna's interest in affordable housing is not purely altruistic. If neighborhoods deteriorate and communities crumble, business will suffer. And a housing shortage eventually becomes a labor shortage. If people can't afford to live where we do business, the pool of workers and customers we need to prosper will shrink. This is a problem we cannot afford to ignore. For too many Americans, what should be a basic aspiration - decent housing - is an impossible dream. Aetna believes business must join as a partner with communities in working toward a goal where one day every family will not have to dream about a place to live - because they will already be in one.

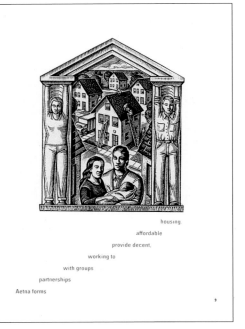

Aetna forms partnerships with groups working to provide decent, affordable housing.

Magazine cover.

DESIGN FIRM: Koepke
Design Group, Magnolia,
Massachusetts

ART DIRECTOR/
DESIGNER: Gary Koepke

WoRld ToUR

A review of worldwide business and technology news published by Dun & Bradstreet Software Volume 1 No. 1 November 1991

Client/Server
New World Order
reengineering
The Soviet Crackup
virtual reality paradigms
Japan programming Germany
data exchange wireless chirality
molecular data storage asteroids
computer viruses high-tech funerals EDI
MIS fuzzy logic refugees open systems
Singapore relational databases buckyballs
food supply 3-D workstations robots on Mars
France Aborigine art GATT Third World demographics
networking string theory Africa CTDs groupware UK

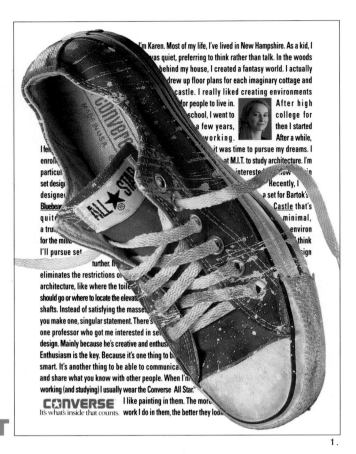

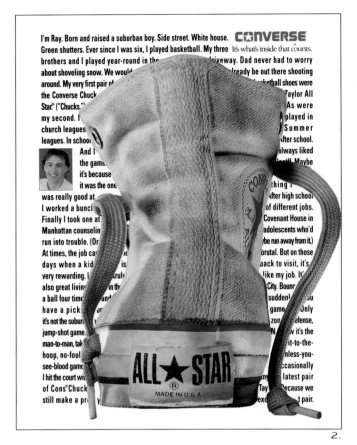

1.

2.

Consumer ad campaign promoting Converse All Star Oxfords (1, 2) and Converse Chuck Taylor All Star Sneakers (3, 4).

AGENCY: Ingalls, Quinn & Johnson, Boston, Massachusetts

CREATIVE DIRECTOR/ ART DIRECTOR: Peter Favat (1-4)

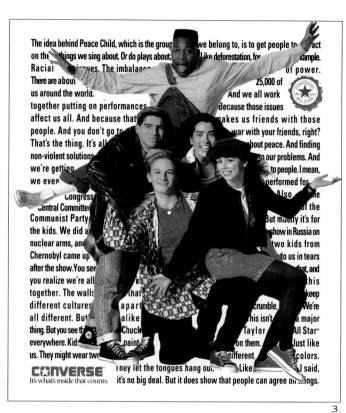

The idea behind Peace Child, which is the group we belong to, is to get people to ___act on the ___things we sing about. Or do plays about. ___Like deforestation, for ___ample. Racial ___issues. The imbalance ___ of power. There are about ___ 25,000 of us around the world. And we all work together putting on performances ___ Because those issues affect us all. And because that ___ ___akes us friends with those people. And you don't go to ___ war with your friends, right? That's the thing. It's all ___ about peace. And finding non-violent solutions ___ to our problems. And we're getting ___ to people. I mean, we even ___ performed for ___ ___ Also ___ ___e Central Committee ___ ___ of the Communist Party ___ But mostly it's for the kids. We did a ___ show in Russia on nuclear arms, and ___ two kids from Chernobyl came up ___ to us in tears after the show. You see ___ that, and you realize we're all ___ this together. The walls ___ that ___ keep different cultures ___apart ___ crumble. We're all different. But ___ alike ___ this isn't ___ a major thing. But you see th___ Chuck ___ Taylor ___ All Star everywhere. Kids ___ paint ___ on them. ___ Just like us. They might wear two ___ different ___ colors. They let the tongues hang out ___ Like ___ I said, it's no big deal. But it does show that people can agree on ___ings.

CONVERSE
It's what's inside that counts.

3.

Maggie and I both thought Flipper was cool when we were kids. The killer whales at Sea World, too. Eventually whales and dolphins became a passion with us. When we started volunteering at the New York Aquarium, it was like all the animals we'd dreamed about were suddenly real. After we ___ ___et out of school, we may teach marine science. Or be a vet. Yeah, when ___ the vet came to monitor the baby beluga whales, that was really ___ ___eat. We recorded their vocalizations. We also fed them squid ___ which we had to de-beak and de-spine. Oh, they loved having ___ their tongues rubbed, too. The thing is, you don't just take ___ care of animals here. You learn how pollution ___ ___ffects their habitat. And how fragile their lives really ___ are. Animals like Nuka here could all be gone ___ ___tomorrow. ___ ___at's why ___ we're ___ here. ___ Joan ___ the ___ ___ailer, too. She ___ wears ___ ___right red Chucks—The Chuck Taylor All Star. A lot of us wear them. Red. Purple. Black. They're comfortable. Washable, too. That's the thing. Because around here you can step in a lot of, well, never mind.

CONVERSE
It's what's inside that counts.

4.

CREATIVE DIRECTOR/ COPYWRITER: Rich Herstek (3, 4)

ART DIRECTOR: Marc Gallucci (1, 2)

COPYWRITERS: Mike Sheehan (1, 2), Don Pogany (1, 2)

TYPOGRAPHER: Michael Babcock (1-4)

PHOTOGRAPHERS: Hiro (1, 2), Pete Stone (3, 4)

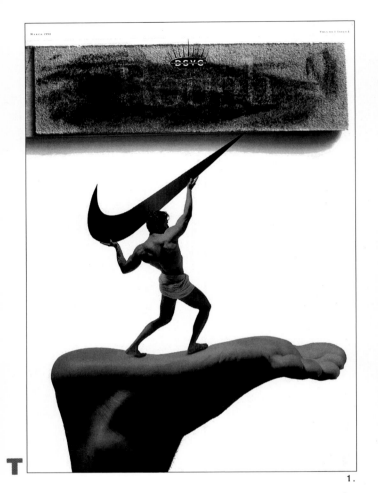

1.

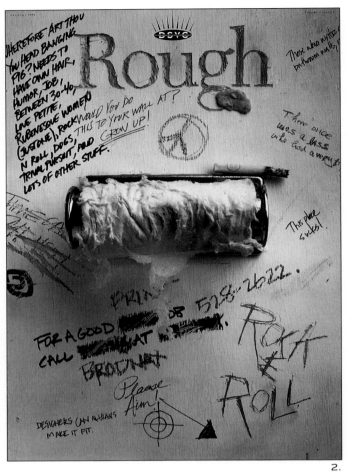

2.

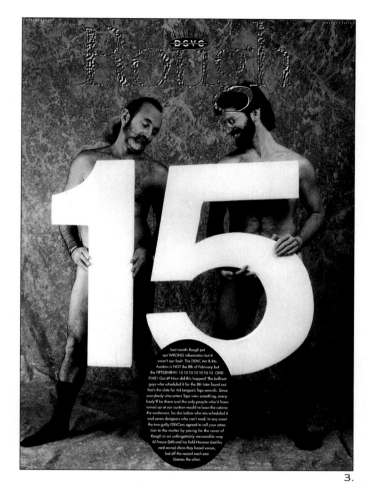

3.

4.

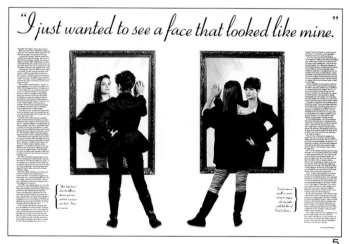

5.

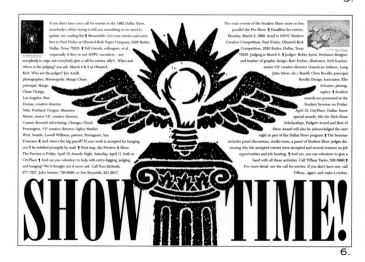

6.

Covers (1-3) and inside spreads (4-6) from the DSVC newsletter.

DESIGN FIRM: Focus 2, Dallas, Texas

ART DIRECTORS/ DESIGNERS: Todd Hart, Shawn Freeman

COPYWRITER: Bill Baldwin

PHOTOGRAPHER: Phil Hollenbeck (1)

2 out of three Freudian complexes satisfied in a single bite homemade goodies in his and hers can only be found at the erotic baker we can duplicate all of your favorite parts of the body and exaggerations are free 582 amsterdam avenue between 88th and 89th streets

T

Do you serve it with coffee, ice cream or a cigarette homemade goodies in his and hers are the specialty at the erotic baker with our desserts, the last thing your guests will be looking at are the spots on your glasses 582 amsterdam avenue between 88th and 89th streets in new york city

give him a cake that looks like it jumped out of a girl homemade goodies in his and hers made fresh daily at the erotic baker where even if you can't get it, at least you can have it for dessert 582 amsterdam avenue in new york city

Series of small promotional posters.
DESIGN FIRM: Olly Olly Ox &
Free, New York, New York
ART DIRECTORS/
COPYWRITERS: Emil
Wilson, Sharilyn Asbahr
DESIGNER: Emil Wilson

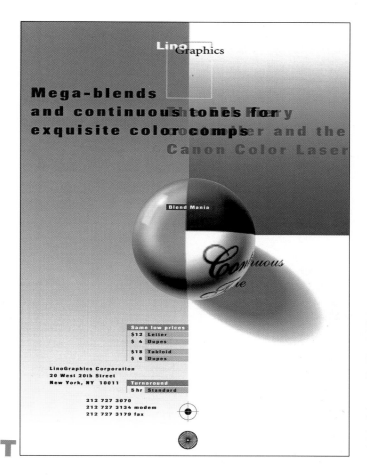

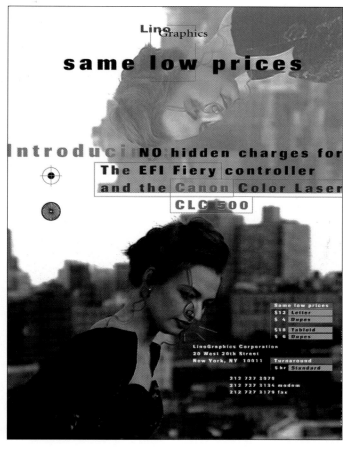

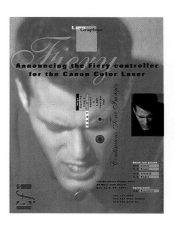

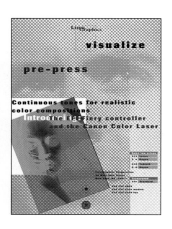

Giveaway color prints promoting the Fiery controller, a new piece of laser-copying equipment.

DESIGN FIRM: KODE Associates, Inc., New York, New York

DESIGNER: William Kochi

1.

2.

Covers (1, 2) and inside spreads (3-6) from 1990 annual report which was produced in six different language versions.

DESIGN FIRM: Frankfurt Gips Balkind, New York, New York
ART DIRECTORS: Aubrey Balkind, Kent Hunter
DESIGNERS: Kent Hunter, Ruth Diener

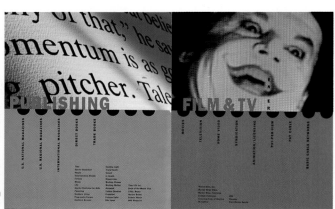

3.

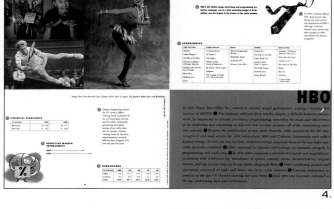

4.

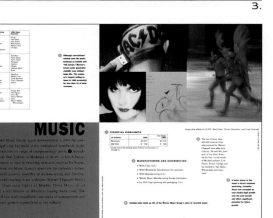

5.

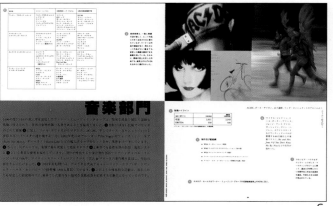

6.

Cover (1), front (2) and
back (3) of accordion-fold
1991 annual report.

DESIGN FIRM: Samata
Associates, Dundee, Illinois

ART DIRECTOR: Pat
Samata

DESIGNERS: Greg Samata,
Pat Samata

PHOTOGRAPHER: Marc
Norberg

1.

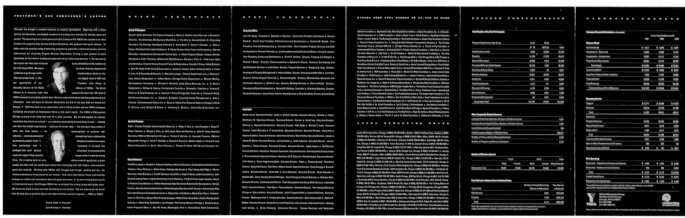

2.

3.

Cover of exhibition catalog.

DESIGN FIRM: McEver

Design, Washington, DC

ART DIRECTOR/

DESIGNER: Caroline

McEver

ARTIST: Tamara de

Lempicka

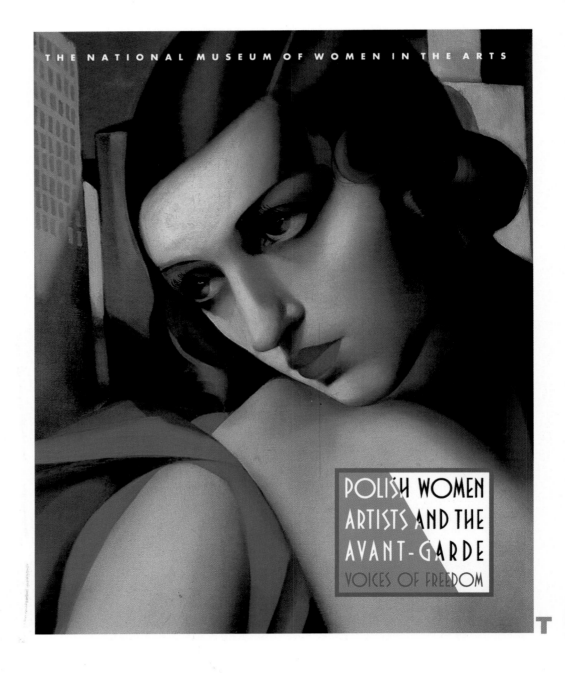

THE NATIONAL MUSEUM OF WOMEN IN THE ARTS

POLISH WOMEN ARTISTS AND THE AVANT-GARDE
VOICES OF FREEDOM

Poster promoting the
inexpensive aspect of
Ambassador Arts' silk-
screening capabilities.
DESIGN FIRM: Pentagram
Design, New York, New
York
PARTNER/DESIGNER:
Paula Scher

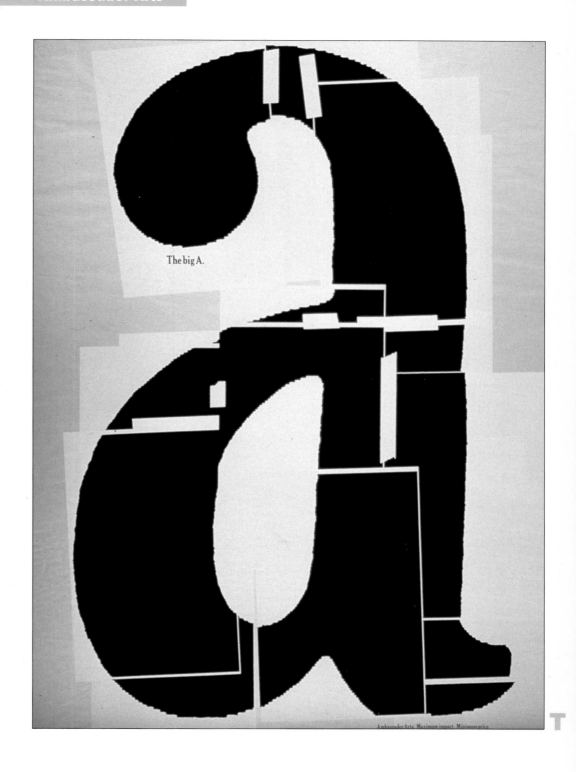

Department page.

ART DIRECTOR: Rudolph C.

Hoglund/Time Magazine,

New York, New York

DESIGNER: Nomi Silverman

ILLUSTRATOR: Mirko Ilic

America Abroad

Strobe Talbott

A State That Deserved to Die

MOSCOW: I've been coming here for 23 years. That turns out to have been about a third of the U.S.S.R.'s life-span. In none of my previous 30-plus visits did I ever think I would outlive the Soviet state. Yet now that it is upon us, the demise of the Soviet Union makes both moral and historical sense.

A country is, among other things, an idea, often dressed up as an ism. The U.S.S.R., a hodgepodge of would-be nation states, was based on an outmoded idea, imperialism, and a modern one, totalitarianism. There was in the minds of those old men in the Kremlin the conceit, personified and perfected by Stalin, that fear makes the world go round; fear can make the worker work, the farmer farm, the writer write and, of course, the Latvian, the Armenian, the Uzbek and the Ukrainian all take orders from Moscow.

To his lasting credit, Mikhail Gorbachev knew that was a lousy idea. He realized that the chemical reaction between intimidation and sycophancy could not fuel a modern society or allow even a so-called superpower to enter the 21st century as anything other than a basket case. Gorbachev has allowed the beginnings of real politics to take the place of terror, and the concept of real economics to replace the institutionalized inefficiency of central planning and massive subsidization.

With the end of the Soviet idea comes the end of the Soviet Union. There is no reason to mourn the death of a country that killed millions of its own citizens in the collectivization campaign, the purges and the famines that were used as an instrument of government policy.

Still, there is apprehension in the cold, sooty air here. I feel it in the pessimism and snarliness of my Russian friends. Only two other events in this century, World War I and World War II, have had an impact comparable to that of the Second Russian Revolution. In each of those earlier cases, our side's victory left a vacuum soon filled by new villains with big, bad ideas that made another global showdown inevitable.

World War I put the Prussian military machine out of business and created new nations from the wreckage of the Habsburg Empire. But by humiliating and pauperizing Germany, the victors contributed to the conditions out of which Nazism arose. World War I also so weakened Czarist Russia that a band of conspirators who called themselves Bolsheviks and who had a blueprint to take over the world were able, for starters, to take over the largest country on earth.

The consequences of World War II were also ambiguous. It destroyed the Third Reich and the Empire of the Rising Sun, but it made possible Stalin's conquest of Eastern Europe and Mao's triumph in China.

Now the cold war is over, and the good guys have won again. But can the winners this time break the pattern of the past? More to the point, will the U.S. take the lead in ensuring that the West does everything in its power to bring about a transition to democracies and free markets in Eurasia?

Karl Marx was wrong about a lot, but he was right about one thing: politics is born of economics. The political stability of the new Commonwealth of Independent States will require steady, substantial infusions of cash, credits and know-how from outside.

The U.S. and its allies in the cold war spent trillions of dollars keeping the Soviet Union from blowing up the world. For a fraction of that amount, the West can help prevent the former Soviet Union from blowing itself up, with all the political—and perhaps literal—fallout that would mean for the rest of the world.

Having slain the dragon of international communism, the U.S. is now flirting with the distinctively American bad idea of isolationism, just as it did after the First World War. This turning inward is now, as it was then, dangerously shortsighted. If worse comes to worst here, Boris Yeltsin may give way to a Russia-Firster like Vladimir Zhirinovsky, who has fascistic tendencies, territorial ambitions and an ominously large popular following. The U.S. might then find itself dragged back into another open-ended international crisis that would make the meagerness of its current aid program seem penny-wise and pound-foolish. After all, the Marshall Plan and other programs to reconstruct Germany and Japan after World War II were arguably as important to avoiding World War III as was the containment of communism.

It's also worth remembering that those first two world-transforming events, the conflagrations of 1914-18 and 1939-45, resulted in the loss of approximately 60 million lives. The political miracle of 1989-91 has also had its victims: scores were killed in the crackdowns in Tbilisi, Baku, Vilnius and Riga, and three young men were martyred in the August coup. But large-scale outbreaks of violence have been fairly isolated everywhere except in the ethnic conflict over Nagorno-Karabakh, the Armenian enclave in Azerbaijan. By and large, the Soviet Union has given up the ghost of the totalitarian idea with remarkably little bloodshed.

Usually when countries and empires die, they take vast numbers of their own people with them. So far, at least, the U.S.S.R. is an exception. Keeping it so is a challenge not only for its new leaders but for the rest of the world as well. ■

MIRKO ILIC FOR TIME

The decadent 50

Opening spread from an article on the 50 most decadent events, people and things from the past year.

ART DIRECTOR: Scott Menchin, New York, New York

DESIGNERS: Scott Menchin, Eric Rochow

It's in here. And it's no smaller than a tumor that's found in a real breast. The difference is, while searching for it in this ad could almost be considered fun and games, discovering the real thing could be a matter of life and death. Breast cancer is one of the most common forms of cancer to strike women. And, if detected at an early enough stage, it's also one of the most curable. That's why the American Cancer Society recommends that women over forty have a mammogram at least every other year, and women under forty have a baseline mammogram between the ages of 35 to 39. You see, a mammogram can discover a tumor or a cyst up to three years before you'd ever feel a lump. In fact, it can detect a tumor or a cyst no bigger than a pinhead. Which, incidentally, is about the size of what you are searching for on this page. At Charter Regional in Cleveland, you can have a mammogram performed for just $101. Your mammogram will be conducted in private, and your results will be held in complete confidence and sent directly to your doctor. After your mammogram, a trained radiology technician will meet with you individually and show you how to perform a breast self-examination at home. And, we'll provide you with a free sensor pad, a new exam tool that can amplify the feeling of anything underneath your breast. Something even as small as a grain of salt. If you would like to schedule a mammogram, just call Charter's Call for Health at 593-1210 or 1-800-537-8184. Oh, and by the way, if you haven't found the lump by now, chances are, you're not going to. It was in the 17th line. The period at the end of the sentence was slightly larger than the others. So think about it, if you couldn't find it with your eyes, imagine how hard it would be to find it with your hands.

CAN YOU FIND THE LUMP IN THIS BREAST?

CHARTER REGIONAL MEDICAL CENTER

CALL FOR HEALTH

5 9 3 . 1 2 1 0

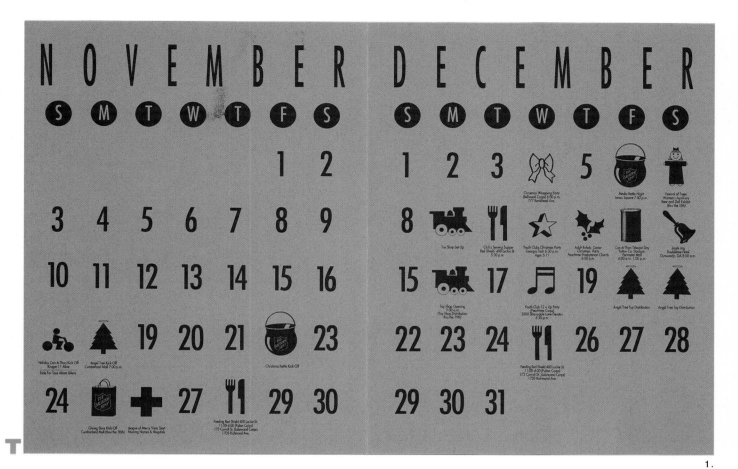

1.

2.

3.

Cover of press-kit folder (2), and cover (3) and inside calendar spread (1) from brochure contained in kit.

DESIGN FIRM: Henderson Advertising, Atlanta, Georgia

ART DIRECTOR: Elizabeth O'Dowd

COPYWRITER: Scott Sheinberg

PHOTOGRAPHER: Bryan Morehead

Billboard series.

AGENCY: Evans

Advertising, Salt Lake City,

Utah

ART DIRECTOR/

DESIGNER: Steve Cardon

COPYWRITER: Bryan

DeYoung

PHOTOGRAPHER: Ed

Rosenburger

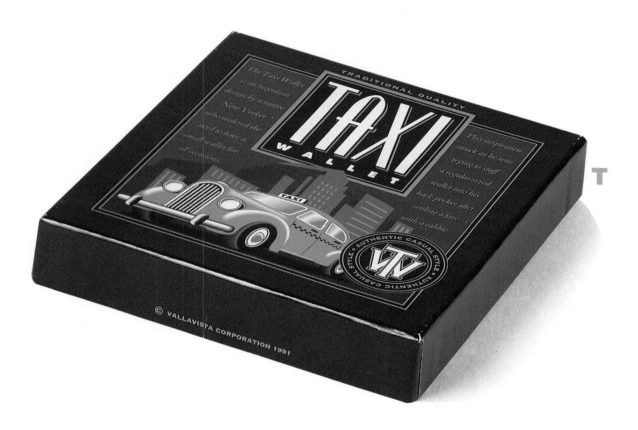

Package for a small wallet

for men and women.

DESIGN FIRM: Bergman

Design, San Francisco,

California

ART DIRECTOR/

DESIGNER/ILLUSTRATOR:

Mark Bergman

Performance poster.

DESIGN FIRM: Market

Sights, Inc., Washington, DC

DESIGNER: Marilyn

Worseldine

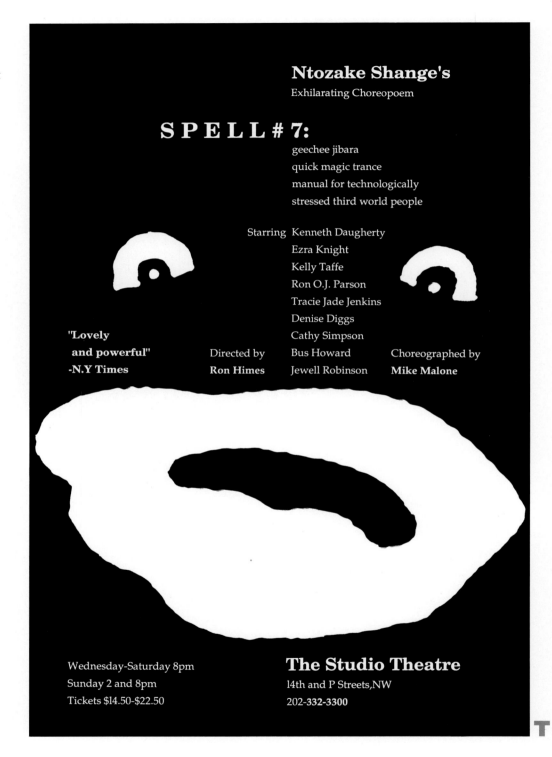

Ntozake Shange's

Exhilarating Choreopoem

SPELL # 7:

geechee jibara
quick magic trance
manual for technologically
stressed third world people

Starring Kenneth Daugherty
Ezra Knight
Kelly Taffe
Ron O.J. Parson
Tracie Jade Jenkins
Denise Diggs
Cathy Simpson

"Lovely
 and powerful"
-N.Y Times

Directed by
Ron Himes

Bus Howard
Jewell Robinson

Choreographed by
Mike Malone

Wednesday-Saturday 8pm
Sunday 2 and 8pm
Tickets $14.50-$22.50

The Studio Theatre

14th and P Streets,NW
202-**332-3300**

Poster announcement for a pool-party fundraiser.
ART DIRECTOR/
DESIGNER: Carter Weitz,
Lincoln, Nebraska
COPYWRITER: John Benson
PHOTOGRAPHY: Rush Studios

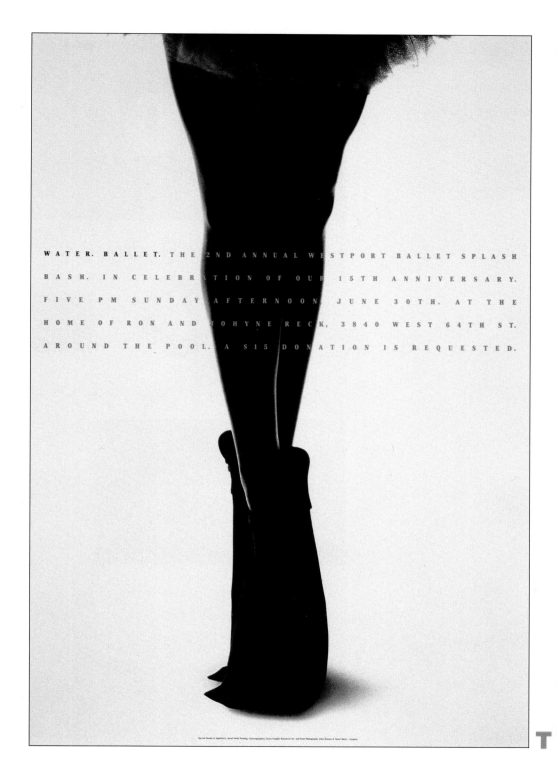

Cover and inside spreads from promotional brochure.
DESIGN FIRM: The Puckett Group, St. Louis, Missouri
ART DIRECTOR: Eric Thoelke
COPYWRITER: Alan Gold

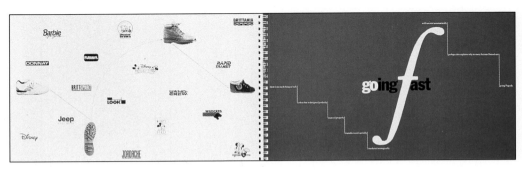

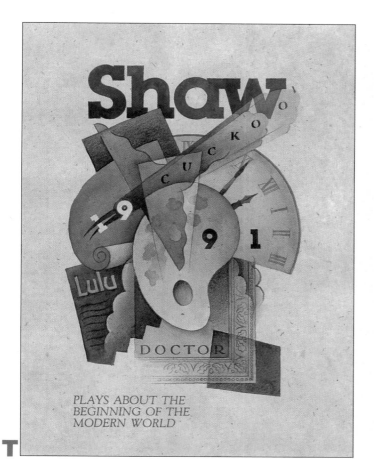

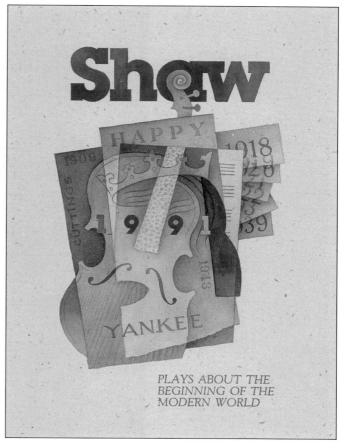

Promotional postcards.

ART DIRECTOR: Scott

McKowen

DESIGNER/ILLUSTRATOR:

Scott McKowen, Lansing,

Michigan

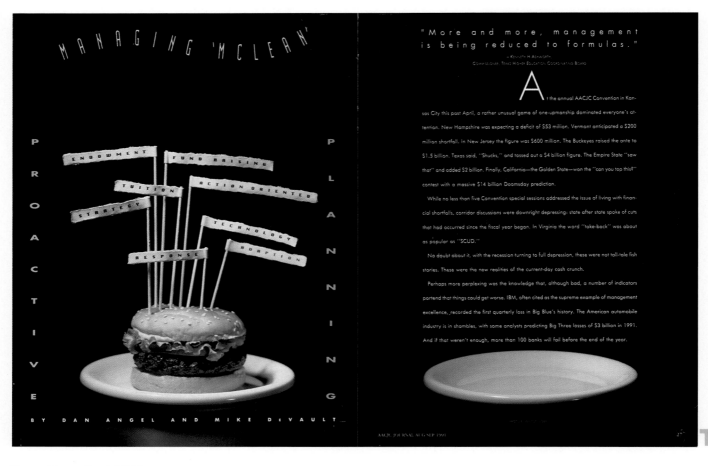

Spread from the AACJC

Journal.

DESIGN FIRM: The

Magazine Group,

Washington, DC

ART DIRECTOR/

DESIGNER: Glenn Pierce

PHOTOGRAPHER: Welton

Doby

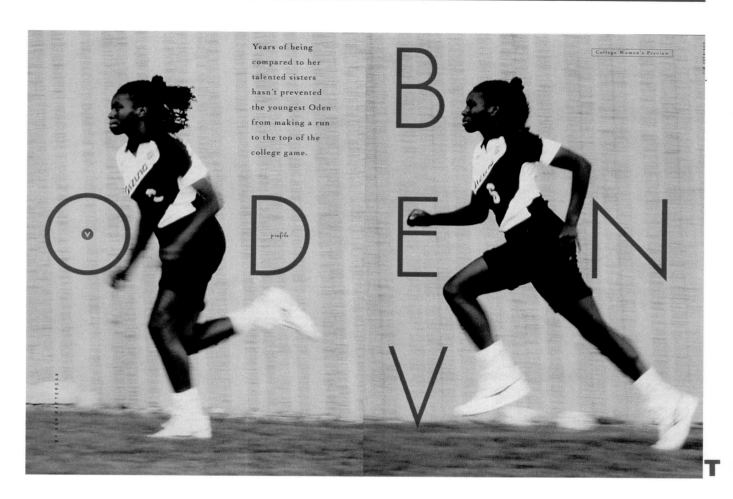

Years of being compared to her talented sisters hasn't prevented the youngest Oden from making a run to the top of the college game.

profile

"College Women's Preview"

spread.

DESIGN FIRM:

Smith, Smith+Smith,

Hermosa Beach, California

ART DIRECTOR:

Dwight Smith

PHOTOGRAPHER:

Tim Defrisco

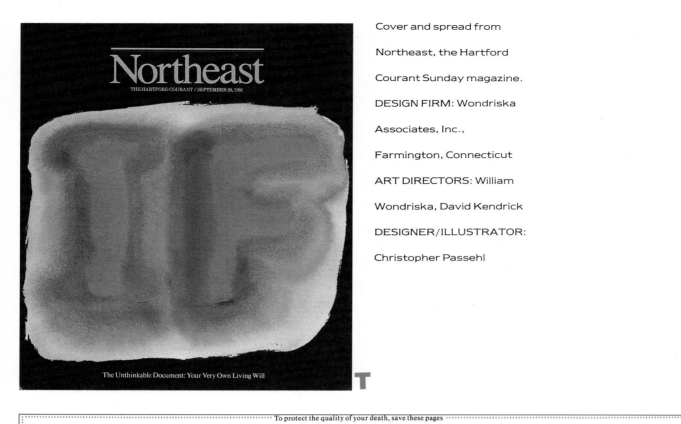

Cover and spread from Northeast, the Hartford Courant Sunday magazine.

DESIGN FIRM: Wondriska Associates, Inc., Farmington, Connecticut

ART DIRECTORS: William Wondriska, David Kendrick

DESIGNER/ILLUSTRATOR: Christopher Passehl

To protect the quality of your death, save these pages

If the time ever comes

Living Will and Appointment of a Health-Care Agent

Living Will

 the time comes that I am incapacitated to the point that I can no longer actively take part in decisions for my own life, and am unable to direct my physician as to my own medical care, I wish this statement to stand as a testament of my wishes.

"I, _____ , request that, if my condition is deemed terminal or if I am determined to be permanently unconscious, I be allowed to die and not be kept alive through life-support systems. By terminal condition, I mean that I have an incurable or irreversible medical condition which, without the administration of life-support systems, will, in the opinion of my attending physician, result in death within a relatively short time. By permanently unconscious, I mean that I am in a permanent coma or persistent vegetative state that is an irreversible condition in which I am at no time aware of myself or the environment and show no behavioral response to the environment. The life-support systems which I do not want include, but are not limited to:

Artificial respiration
Cardiopulmonary resuscitation
Artificial means of providing nutrition and hydration

I do not intend any direct taking of my life, but only that my dying not be unreasonably prolonged."

Other specific requests:

Appointment of a Health-Care Agent

"I appoint _____ to be my health-care agent. If my attending physician determines that I am unable to understand and appreciate the nature and consequences of health-care decisions and to reach and communicate an informed decision regarding treatment, my health-care agent is authorized to: _____

(1) Convey to my physician my wishes concerning the withholding or removal of life-support systems.

(2) Take whatever actions are necessary to ensure that my wishes are given effect.

If this person is unwilling or unable to serve as my health-care agent, I appoint _____ to be my alternative health-care agent.

These requests are made after careful reflection, while I am of sound mind."

_____ (Signature)
_____ (Date)

This document was signed in our presence, by the above-named _____ , who appeared to be 18 years of age or older, of sound mind and able to understand the nature and consequences of health-care decisions at the time the document was signed.

_____ (Witness)
_____ (Address)
_____ (Witness)
_____ (Address)

My Living Will

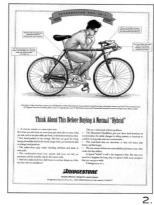

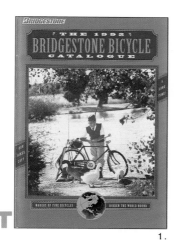

Cover (1) and inside spreads (3-6) from 1992 Bridgestone bicycle catalog. Newspaper ad (2).

DESIGN FIRM: Defrancis Studio, Cambridge, Massachusetts

ART DIRECTOR: Lisa Defrancis

DESIGNER: Greg Galvan

COPYWRITER: Grant Petersen

ILLUSTRATOR: George Retsek

1.

2.

3.

4.

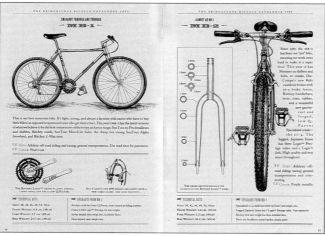

5.

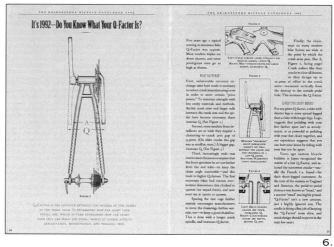

6.

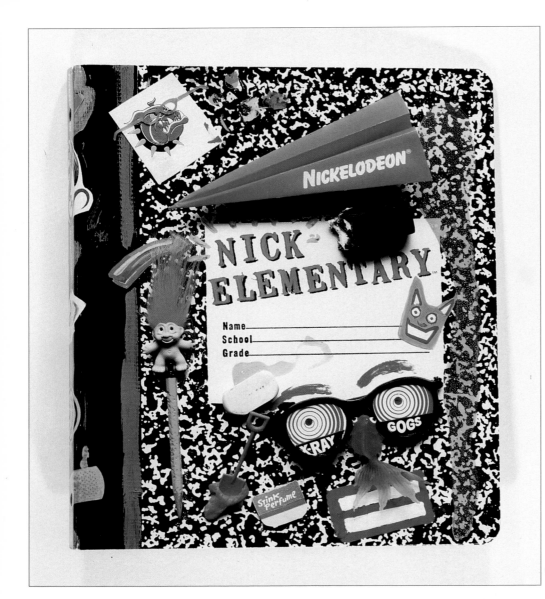

Cover and inside pages from Nickelodeon Elementary promotion.

DESIGN FIRM: MTV Networks/Creative Services, New York, New York

CREATIVE DIRECTOR: Leslie Leventman

ART DIRECTOR: Laurie Kelliher

DESIGNERS: Laurie Kelliher, Michelle Willems, Cheri Dorr, Vinnie Sainato

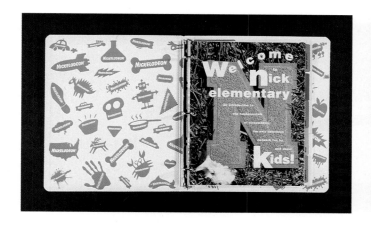

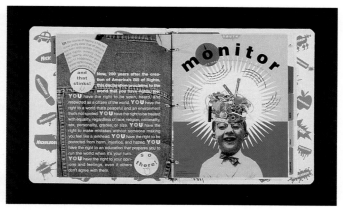

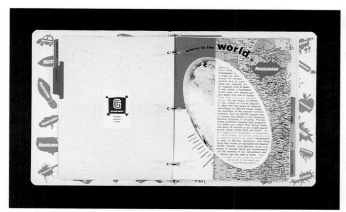

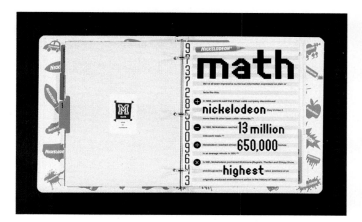

Spreads and single page
from various issues.
ART DIRECTOR: Fred
Woodward/Rolling Stone,
New York, New York

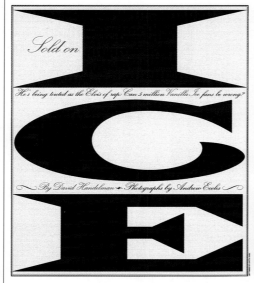

1.

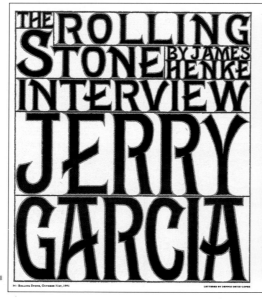

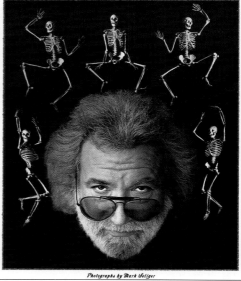

2.

44

DESIGNERS: Debra Bishop
(1, 4-6), Fred Woodward
(2), Catherine Gilmore-
Barnes (3)

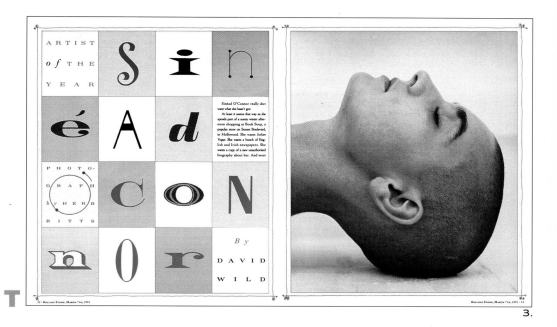

3.

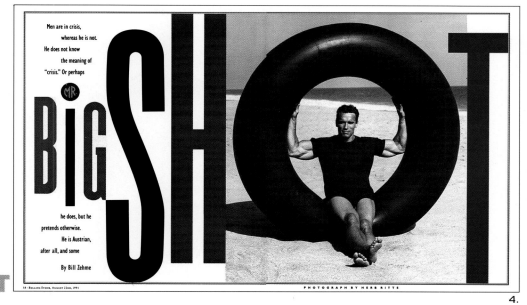

4.

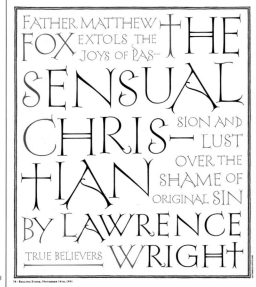

FATHER MATTHEW FOX EXTOLS THE JOYS OF PAS- THE SENSUAL CHRISTIAN SION AND LUST OVER THE SHAME OF ORIGINAL SIN BY LAWRENCE WRIGHT

TRUE BELIEVERS

78 · ROLLING STONE, NOVEMBER 14TH, 1991

PHOTOGRAPHS BY DAN WINTERS

5.

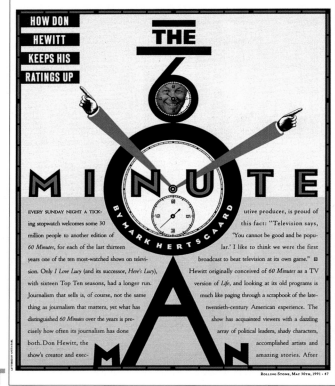

HOW DON HEWITT KEEPS HIS RATINGS UP

THE 6 MINUTE MAN

BY MARK HERTSGAARD

EVERY SUNDAY NIGHT A TICK-ing stopwatch welcomes some 30 million people to another edition of *60 Minutes*, for each of the last thirteen years one of the ten most-watched shows on televi-sion. Only *I Love Lucy* (and its successor, *Here's Lucy*), with sixteen Top Ten seasons, had a longer run. Journalism that sells is, of course, not the same thing as journalism that matters, yet what has distinguished *60 Minutes* over the years is pre-cisely how often its journalism has done both. Don Hewitt, the show's creator and exec-utive producer, is proud of this fact: "Television says, 'You cannot be good and be popu-lar.' I like to think we were the first broadcast to beat television at its own game." Hewitt originally conceived of *60 Minutes* as a TV version of *Life*, and looking at its old programs is much like paging through a scrapbook of the late-twentieth-century American experience. The show has acquainted viewers with a dazzling array of political leaders, shady characters, accomplished artists and amazing stories. After

ROLLING STONE, MAY 30TH, 1991 · 47

6.

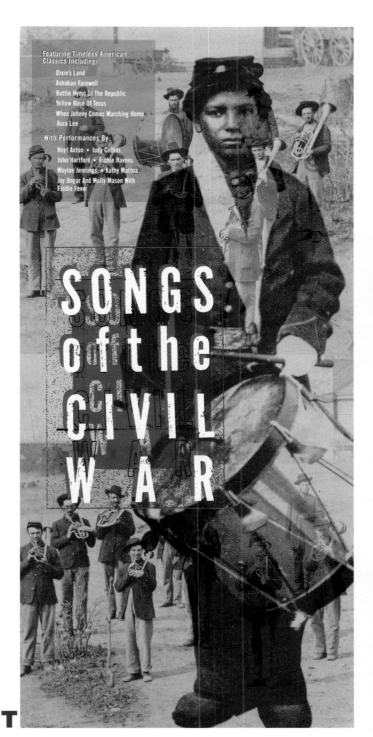

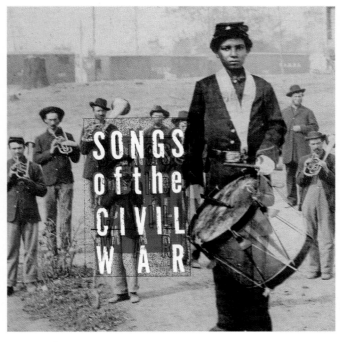

CD packaging.

ART DIRECTOR: Nicky Lindeman/Sony Music, New York, New York

Designer bludgeons type guy to death.

"He was late. Again. I couldn't take it anymore."

"And the job was ugly," screamed a local designer as she was led away by police.

"They're always late. The type comes in here when they feel like it. And I do a lot of business with them. So yesterday I snapped. The type shows up at 2:30, the deadline is 4:00, and there are *mistakes!*

"It's like a monkey set the type. Just slapped it out. Doesn't anybody out there care anymore?"

The graphic designer's lawyers say she'll be acquitted, no problem.

"After I make bail, I'm going to start using these guys, Scott Group," announced the graphic designer. "They've been sending us these little type jobs all week. I should've used them Monday. The job would have been perfect, and I wouldn't have had to kill that type guy. Even though he deserved it. What ticks me off is I got blood all over my layouts.

"Call these guys at Scott Group, unless you're in the mood to shoot someone. 777-3832. Or fax them a job you need in a big hurry, that you need right, 722-4053."

IF YOU HAD ORDERED TYPE FROM SCOTT GROUP IT WOULD BE HERE ALREADY.

AND IT WOULD BE PERFECT.

Hand-delivered promotion pieces for a typographer. DESIGN FIRM: Periwinkle Design, Denver, Colorado

ART DIRECTOR: Barbara Scott

DESIGNER: Heidi Krakauer

COPYWRITER: Richard Graglia

This is the third day our type got here ahead of your type.

TODAY IS WEDNESDAY. KERNING DAY.

LOOK WHAT WE'VE DONE TO THESE NATURALLY BAD WORD COMBINATIONS.

T's are Totally Tattering, Tyrannical and Tremendously Tempestuous Tumors. So there.

▼ ▼ ▼

V's are no vacation either.

V's are Very Vacant and Voicy.

▼

Sometimes you just want to slap 'em.

■ WHAT ABOUT A'S?
AWESOME, ACUTELY ATTENTION-GETTING LETTERS.
■

SCOTT GROUP — 777-3832 • FAX — 722-4053

CLIENT: Client's Name (customized) JOB DESCRIPTION: Friday Type Delivery DISK: H1: 90
DATE: 3-15-91 TYPEFACES: Esprit, Triumvirate Extended, Berkeley, Univers 49, Gill Sans, Microstyle FILE: print-5

It's **Friday**

You've seen what we can do with type every day this week.

NOW

We want to see what you can do.

— — — — — — **N**ext Monday you could be getting another early morning arrival from Scott Group. Another perfect job. But this time it could be a live job from you. The ultimate test.

Call us today, 777-3832. In case you've forgotten, we're the type fanatics. A company full of people who were born with an urge to craft type. Like you were born to design. You love what you do. We love what we do. And when we do a job for you, you'll love what we do, too.

▶ It's **Friday.** You're in a good mood, ready for some excitement. Ready for a change. Then you're ready for us. We don't need to tell you we're the finest typographers in town. You've been seeing it all week. And for five days in a row, we've gotten here before your type, with no mistakes.

Let's do one for real. Call me, Barb Scott, at 777-3832. Or fax us a job right now, 722-4053.

By the way, have a good weekend. (When you start doing business with Scott Group, you'll have even better weekends, because we make you look good all week long.)

IF YOU HAD ORDERED
T Y P E
FROM SCOTT GROUP

IT WOULD BE HERE ALREADY.

AND IT WOULD BE
PERFECT.

SCOTT GROUP — 777-3832 • FAX — 722-4053

CLIENT: Client's Name (customized) JOB DESCRIPTION: Monday Type Delivery DISK: H1: 90
DATE: 3-11-91 TYPEFACES: Bodoni, Gill Sans, Garamond, Microstyle, Flemish Script, Copperplate, Leawood, Triumvirate, etc. FILE: print-1

Did you order this type?

Hey, I didn't order this.
Looks good though.
Clean.
In focus.

Where'd this stuff come from, anyway? And why'd it get here before my type? What's going on?

Good kerning.

In fact, the best I've seen

in a while, and I didn't have

to scream at them. I'm

getting fed up with

screaming at

suppliers.

▶ AND ANOTHER THING ABOUT THIS TYPE. ◀
N O M I S T A K E S.

So Where'd it come from?

. .
IT CAME FROM US. SCOTT GROUP
WE WANT YOU TO USE US FOR
YOUR TYPE BECAUSE WE'RE GOOD.
WE'RE FANATICAL TYPE CRAFTERS.
WE WORK WITH IMPOSSIBLE DEADLINES.
WE DELIVER. WE DO TYPE RIGHT.

And we're here already.
Something to think about.
Test us for real.
Barb Scott, 777-3832.
Fax, 722-4053.

IF YOU HAD ORDERED
TYPE FROM SCOTT GROUP
IT WOULD BE HERE ALREADY.
AND IT WOULD BE PERFECT.

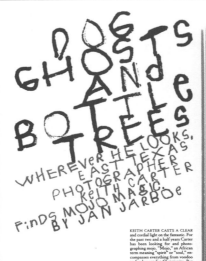

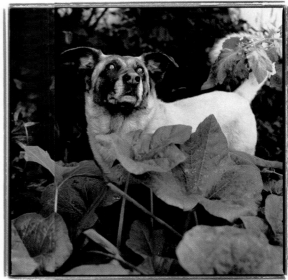

KEITH CARTER CASTS A CLEAR
and cordial light on the fantastic. For
the past two and a half years Carter
has been looking for and photo-
graphing mojo. "Mojo," an African
term meaning "spirit" or "soul," en-
compasses everything from voodoo
to fundamentalist Christianity. But
to Carter, who heard the term all his
life growing up in East Texas, "mojo"
means "magic." He's interested in
anything that glows—images that
seem to have an inner light.

For example, the dog with the shin-
ing eyes on the page to your right
is no ordinary dog but a dog ghost.
In certain parts of East Texas, peo-

DOG GHOST

Spreads from a
photographer's portfolio.
ART DIRECTOR: D.J.
Stout/Texas Monthly,
Austin, Texas
DESIGNER: D.J. Stout
PHOTOGRAPHER: Keith
Carter
TYPOGRAPHER: Patrick
Stout, age 5

DOMINOES

BOTTLE TREE

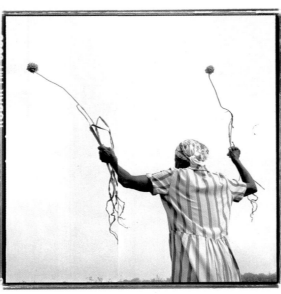

waist, his body swaying back and
forth. Carter had no idea what the
man was doing (mojo is always mys-
terious), but he stopped and took the
photograph on page 106. "I wish I
had gotten closer," says Carter, "but
to tell you the truth, I was scared to."
The "bent man" looked up when the
camera clicked but then immediate-
ly returned to his hanging position.

In voodoo culture, objects of pro-
tection are called jujus. Carter met
up with many kinds of jujus: red
pouches filled with herbs, brooms
over doorways, a knife and fork care-
fully laid in the shape of a cross on
clean white bed sheets. The most
powerful juju of all, Carter learned,
is the Bible. He looked for the se-
cret spiritual lives that country peo-
ple lead. The woman waving garlic
stalks against the sky is presumably
shooing away evil. ("Garlic is good
for what ails you," says Carter.) On
the road to Crockett he saw a tree
decorated with bottles. Bottle trees
are like dog ghosts. Both are ves-
sels for spirits. "The theory," says
Carter, "is if you put brightly col-
ored bottles on the tree, the bot-
tles will attract evil and the bad spir-
its can't get out."

He learned that spontaneity is its
own reward. Another day Carter met
a small black boy with watery eyes
and asked permission to take his pic-
ture. The boy agreed. Carter then
asked if the boy had a picture of Dr.
Martin Luther King. "No," said the
boy, "but I have a picture of George
Washington." In Carter's photo-
graph the boy clutches the heavily
lacquered frame of George Wash-
ington's picture. "That just about
broke my heart," recalls Carter. Ul-
timately, mojo is power, and the pow-
er at work in these photographs is
that every time the heart of mojo
is touched, the power expands.

These images reflect Carter's own
character: insistent but nonjudgmen-
tal; self-revealing but never cynical.
"I do these kind of photographs for
my own internal sustenance," he
says. Carter has lived in Beaumont
since he was three years old. His
father deserted the family, and it fell
to his mother to hold things together,
both financially and emotionally. Jane
Carter started a photography studio,
earning a living for her family by
photographing children.

As a boy, Carter worked as a
framer in his mother's studio, but he

GARLIC

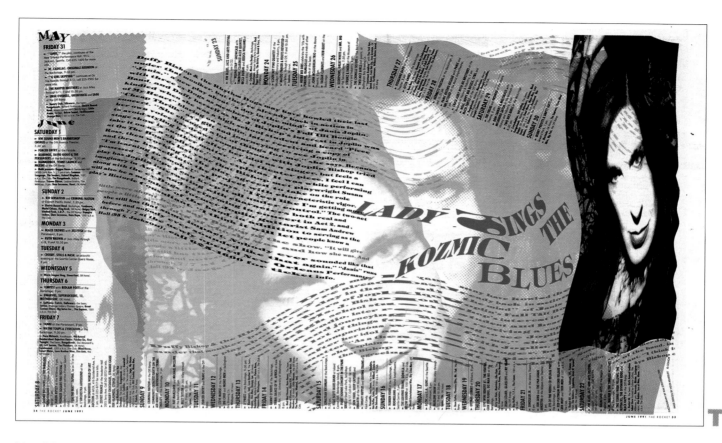

Monthly events calendar
spread.

ART DIRECTOR: Art
Chantry/The Rocket,
Seattle, Washington

DESIGNER: Heidi Kearsley

PHOTOGRAPHER: Kim
Stringfellow

Book jacket.

ART DIRECTOR: Barbara Anderson

ILLUSTRATOR/ LETTERER: Linda Scharf, Boston, Massachusetts

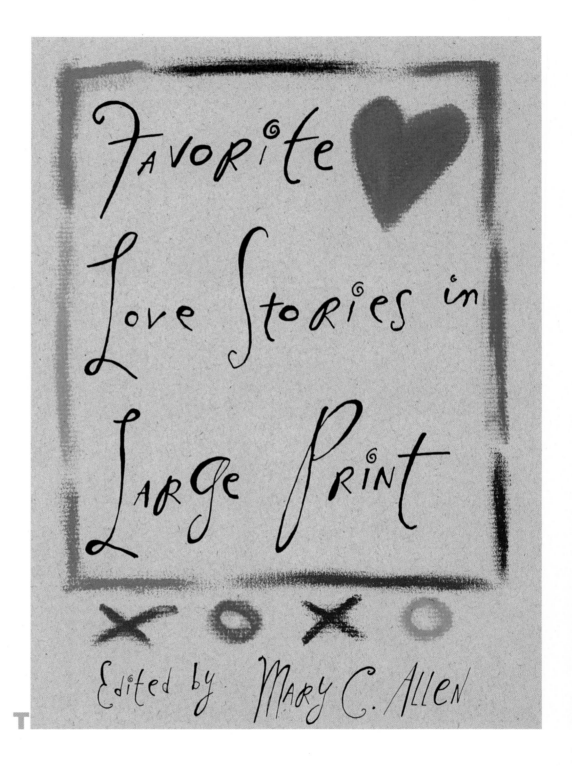

Ad for a restaurant.

AGENCY: Frankenberry,

Laughlin & Constable,

Milwaukee, Wisconsin

CREATIVE DIRECTOR: John

Constable

ART DIRECTOR: Scotti

Larson

COPYWRITER: Brad Berg

ILLUSTRATOR: Scotti

Larson

FRESH ICEBERG, ROMAINE AND LEAF LETTUCE TOSSED WITH SPINACH, TOMATOES, EGGS AND HOMEMADE CROUTONS; ALL WITH YOUR CHOICE OF DRESSING. WE RECOMMEND CASUAL.

KEN ELLIOT'S. CASUAL FINE DINING.
158 East Juneau, Milwaukee, Wisconsin 414.274.7204

Self-promotional packages

distributed to clients at

Thanksgiving.

DESIGN FIRM: Advent

Design Agency, Inc.,

Elkhart, Indiana

ART DIRECTOR/

DESIGNER: Ron

Schemenauer

COPYWRITER: Abraham

Lincoln

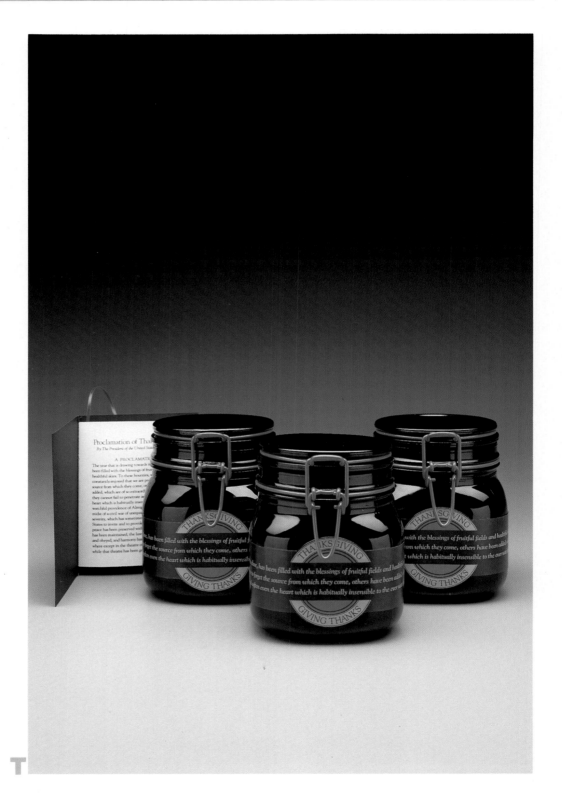

Point-of-purchase display for medicated lip balm.
ART DIRECTOR: Leslie Winn/Solaray, Inc., Ogden, Utah
DESIGNER: Michelle J. Bastian

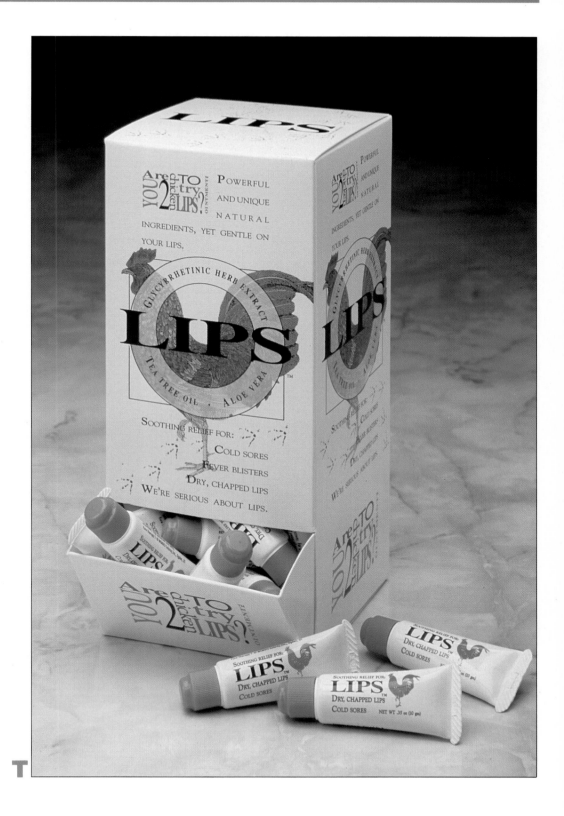

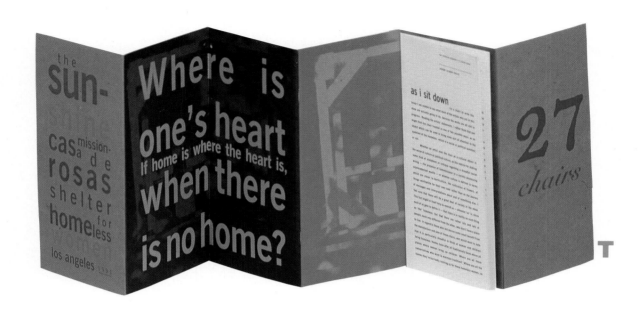

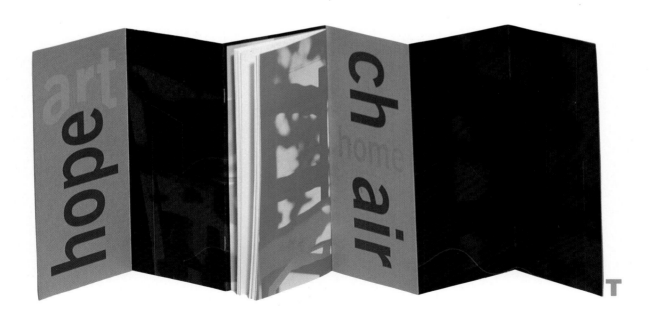

Catalog for a benefit art auction of 27 chairs designed especially for the auction.

DESIGN FIRM: SoS, Los Angeles, Los Angeles, California

ART DIRECTOR/ DESIGNER/ PHOTOGRAPHER: Susan Silton

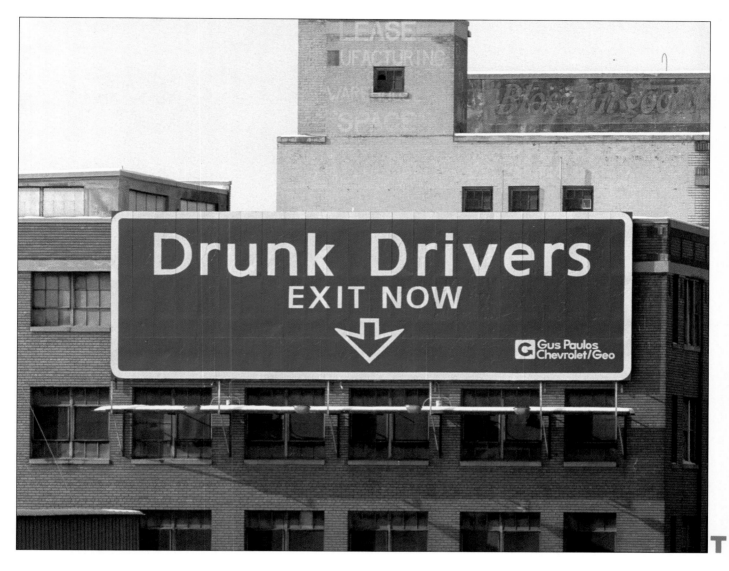

Controversial anti-drunk-driving billboard.

AGENCY: Evans Advertising, Salt Lake City, Utah

ART DIRECTOR/

COPYWRITER: Dick Brown

Paulos wants to exit now from imbroglio caused by 500 South billboard

CONNECTIONS

DENNIS LYTHGOE

It was great while it lasted, but it's gone now. I'm talking about that billboard you couldn't miss on the 500 South I-15 on-ramp.

Anyone exiting the city has noticed its forceful message: DRUNK DRIVERS EXIT NOW.

It was put up at Thanksgiving time. When my sister was recently visiting from Washington, D.C., she said, "Now *that* sign I *like!*"

A lot of other people have felt the same way.

Gus Paulos of Gus Paulos Chevrolet, who is responsible for the billboard, says that he has had literally hundreds of letters and phone calls from people congratulating him for what they consider a service to humanity. Some of them have been "tear-jerkers" — from people who have suffered the effects of alcoholism in their families.

The Utah Department of Transportation, however, feels differently. On Jan. 21, they notified the owner of the billboard, Doug Bagley of A-1 Moving and Storage, that it would have to come down.

"The reasoning," says Bagley, "was pretty valid. Anyone who does outdoor advertising cannot make a replica of a bona fide highway sign. You can't have green and white coloring because it looks identical to a highway sign. So it has to come off or the billboard comes down."

Since Bagley doesn't want to lose the billboard he immediately informed Paulos of the order. Paulos will comply because he has been using the same space, rented from Bagley, for 13 years and doesn't want to lose it either.

But he is a little irritated by the way it was done. He says UDOT didn't even contact him.

"They work through Bagley. Basically, the criticism stems from the idea that you cannot put a sign on the freeway using the highway green to do it. They're afraid that someone is going to exit the freeway there.

"I don't know how they could get over a 10-foot-high wall to do so, but that's what they're afraid of. It's a sign on a small high-rise building, 50 feet off the freeway. What are we saying to the people of Utah? That people are not intelligent enough to recognize real highway signs, and that they would actually try to exit there?"

Bagley says that UDOT does not necessarily think people will try to turn off where there is no exit. On the other hand, after he received the request to take it down, he found "a whole bunch of car parts" in front of his building, indicating there had been an accident in approximately the same place. "Car parts went flying. We *did* have a headlight by our front door."

Paulos would have changed the sign by the first of May anyway.

He usually spends money to advertise, especially during the holidays, about the dangers of drunken driving and has done so for a long time.

"We take and take and take as business people — and this is a way we try to return something to the community.

"The reason to do this is not to sell cars," says Paulos.

He wants the sign to cause people to think seriously about the dangers of driving while under the influence. "If you're an adult and you want to drink, go ahead and drink — but then take a taxi home. Call someone to come and get you. It's so easy to get a ride home."

The ironic part of the story, says Paulos, is that "UDOT threatens us with a lawsuit the same day we receive a national safety award from the national safety people." Paulos received a "gorgeous plaque," an award of excellence, from the Dealer's Safety and Mobility Council, an affiliate of the Highway Users Federation, Washington, D.C.

The award celebrates Paulos' ongoing support of traffic safety.

The award did not stop what Paulos calls "a war" beginning with the UDOT order. Every day from morning until evening, Paulos takes calls on both sides of the issue — which is *not* what he wanted.

All he wanted was to try to save one life.

■ *Dennis Lythgoe's column is published on Mondays, Tuesdays and Thursdays.*

Book covers.

DESIGN FIRM: Peter Good
Graphic Design, Chester,
Connecticut

ART DIRECTOR/
DESIGNER: Peter Good
ILLUSTRATOR: Janet
Cummings Good
TYPOGRAPHY: Comp One

Fundraiser promotion for
the national AIGA
conference in Chicago.
DESIGN FIRM: Kampa
Design, Austin, Texas
ART DIRECTOR: Kelley
Toombs
COPYWRITER: D.J. Stout
DESIGNER/ILLUSTRATOR:
David Kampa

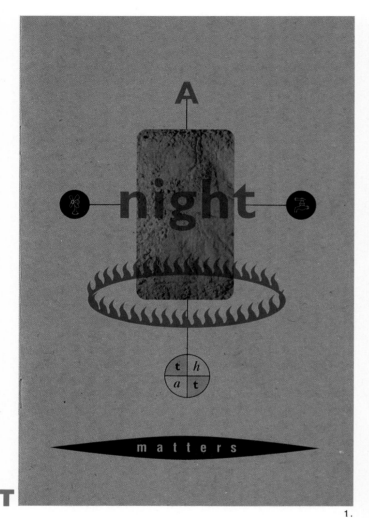

1.

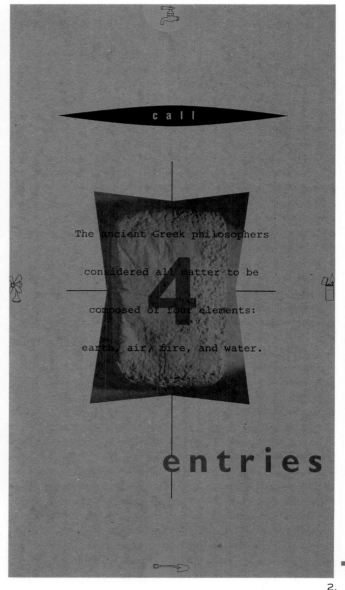

2.

Cover of call-for-entries folder (2), interior inserts symbolizing the four elements (3-6) and awards dinner invitation (1).

DESIGN FIRM: Graffito, Baltimore, Maryland

ART DIRECTORS/ DESIGNERS: Tim Thompson, Morton Jackson, Dave Plunkert

PHOTOGRAPHERS: Morton Jackson, E. Brady Robinson

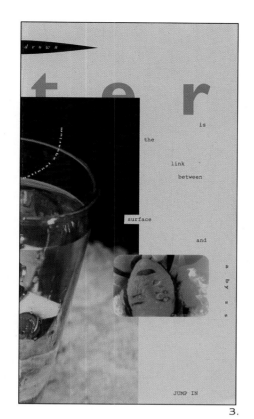

3.

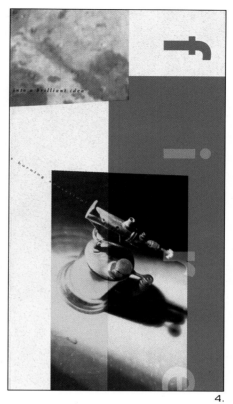

4.

5.

6.

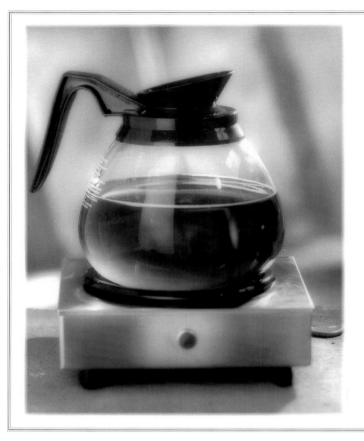

You've just logged your 11th hour on a particularly spiffy spreadsheet. Your partner at the next desk is keying in

critical payroll data. And an associate is in the middle of faxing time-sensitive documents to L.A.

THIS COFFEE POT

Simultaneously, an innocent intern decides to brew a little java. □ Blip. Foosh. Goodbye. Everything goes down

COST THOUSANDS OF

the drain as an electrical circuit overloads. You're out thousands in lost time and information. □ At this point you

DOLLARS. AND IT

can: A. Fire the intern, and feel better for 30 seconds; B. Yell at your building super, and feel better for a minute;

WASN'T EVEN PURCHASED

or, C. Call your PGE business representative and feel better indefinitely. Your PGE rep is your entree into the

BY THE GOVERNMENT.

complex world of enhanced power quality. It's a world where power surges and interruptions are hunted down,

where electrical wiring is checked, equipment is monitored and suggestions are made. Before you know it the

Portland General Electric

most expensive cost associated with [121 SW Salmon St., Portland, OR 97204 (503) 691-1726] your coffee maker will be the coffee.

Ad for electric utility.

AGENCY: Borders, Perrin & Norrander, Portland, Oregon

ART DIRECTOR: Tim Parker

COPYWRITER: Greg Eiden

PHOTOGRAPHER: Dale Windham

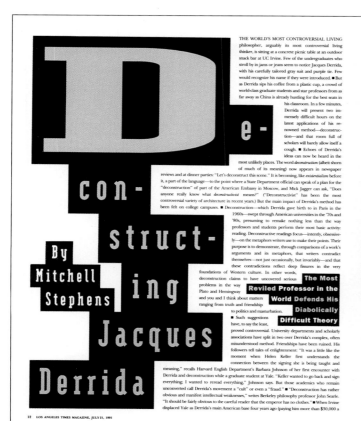

De-con-struct-ing Jacques Derrida

By Mitchell Stephens

THE WORLD'S MOST CONTROVERSIAL LIVING philosopher, arguably its most controversial living thinker, is sitting at a concrete picnic table at an outdoor snack bar at UC Irvine. Few of the undergraduates who stroll by in jams or jeans seem to notice Jacques Derrida, with his carefully tailored gray suit and purple tie. Few would recognize his name if they were introduced. ■ But as Derrida sips his coffee from a plastic cup, a crowd of world-class graduate students and star professors from as far away as China is already hustling for the best seats in his classroom. In a few minutes, Derrida will present two immensely difficult hours on the latest applications of his renowned method—deconstruction—and that room full of scholars will barely allow itself a cough. ■ Echoes of Derrida's ideas can now be heard in the most unlikely places. The word *deconstruction* (albeit shorn of much of its meaning) now appears in newspaper reviews and at dinner parties: "Let's deconstruct this scene." It is becoming, like *existentialism* before it, a part of the language—to the point where a State Department official can speak of a plan for the "deconstruction" of part of the American Embassy in Moscow, and Mick Jagger can ask, "Does anyone really know what *deconstructivist* means?" ("Deconstructivist" has been the most controversial variety of architecture in recent years.) But the main impact of Derrida's method has been felt on college campuses. ■ Deconstruction—which Derrida gave birth to in Paris in the 1960s—swept through American universities in the '70s and '80s, presuming to remake nothing less than the way professors and students perform their most basic activity: reading. Deconstructive readings focus—intently, obsessively—on the metaphors writers use to make their points. Their purpose is to demonstrate, through comparisons of a work's arguments and its metaphors, that writers contradict themselves—not just occasionally, but invariably—and that these contradictions reflect deep fissures in the very foundations of Western culture. In other words, deconstruction claims to have uncovered serious problems in the way Plato and Hemingway and you and I think about matters ranging from truth and friendship to politics and masturbation. ■ Such suggestions have, to say the least, proved controversial. University departments and scholarly associations have split in two over Derrida's complex, often misunderstood method. Friendships have been ruined. His followers tell tales of enlightenment: "It was a little like the moment when Helen Keller first understands the connection between the signing she is being taught and meaning," recalls Harvard English Department's Barbara Johnson of her first encounter with Derrida and deconstruction while a graduate student at Yale. "Keller wanted to go back and sign everything; I wanted to reread everything," Johnson says. But those academics who remain unconverted call Derrida's movement a "cult" or even a "fraud." "Deconstruction has rather obvious and manifest intellectual weaknesses," writes Berkeley philosophy professor John Searle. "It should be fairly obvious to the careful reader that the emperor has no clothes." ■ When Irvine displaced Yale as Derrida's main American base four years ago (paying him more than $30,000 a

The Most Reviled Professor in the World Defends His Diabolically Difficult Theory

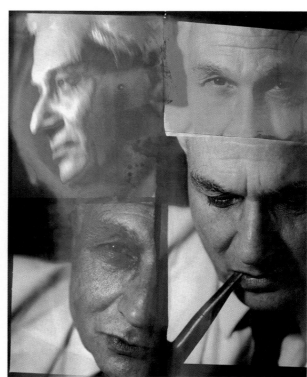

Photographed by James Fee/Shooting Star

Spread from Los Angeles Times Magazine.

ART DIRECTOR: Nancy Duckworth/Los Angeles Times Magazine, Los Angeles, California

DESIGNER: Steve Banks

PHOTOGRAPHER: James Fee/Shooting Star

Packaging.

DESIGN FIRM: The Duffy
Design Group, Minneapolis,
Minnesota
ART DIRECTORS: Joe
Duffy, Todd Waterbury
(Frostbite), Sharon Werner
(Knob Creek Bourbon)

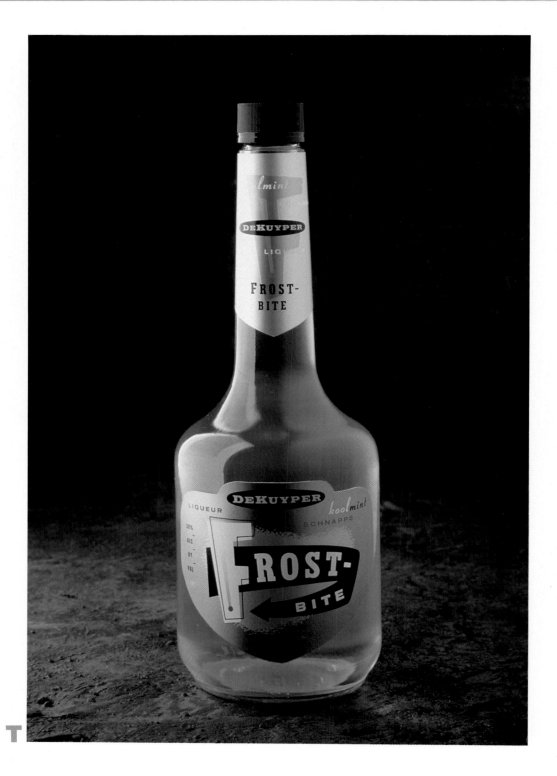

DESIGNERS: Todd
Waterbury (Frostbite),
Sharon Werner (Knob
Creek Bourbon)
ILLUSTRATOR: Todd
Waterbury (Frostbite)

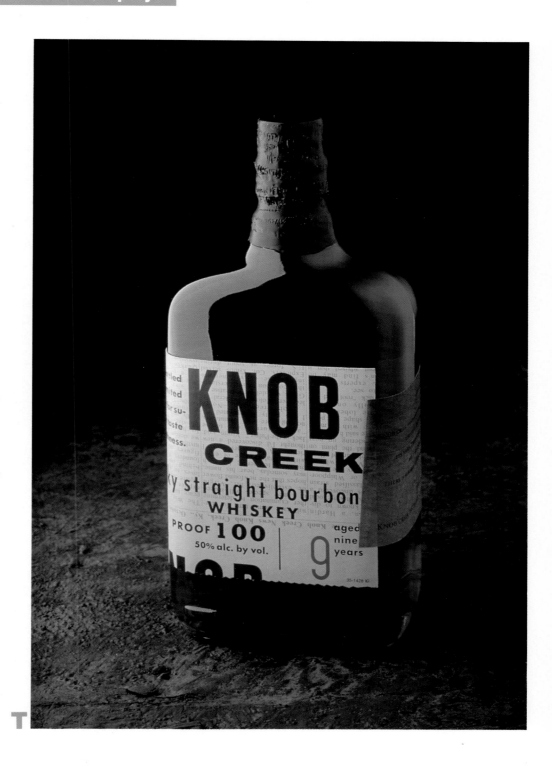

Point-of-purchase

fundraising posters.

AGENCY: The Coates

Agency, Portland, Oregon

ART DIRECTOR: Dave Born

COPYWRITER: Todd Duvall

PHOTOGRAPHER: Greg

Leno

IT'S FUNNY. NOT LONG AGO, 7:30 MEANT another night of cracking open a couple of cold ones and flipping on the tube. What a life. But let me tell you, pal, it wears thin fast. Do my time at work and go home. I mean, everyday I'd put in long hours at a job that was taking me down nowhere boulevard. And for what? Is this all there is, I began to wonder. Yeah, like I could really compete with those young guys with the fancy education and fancy job skills. But that's what the boss was looking for. I guess I was pretty angry at them for getting all the opportunities – not to mention the big bucks. Then it downed on me. They're not the ones I should be mad at. I am. After all, I'm the one who had resigned myself to this lifestyle. Until now, that is. A guy at work (who, by the way, just got another promotion) clued me in about some after-hours business programs right here at the local college. Programs designed to help me learn new job skills and improve the ones I already have. Programs designed around my schedule at work. So I gave 'em a call. They made it possible for me to get the tools I needed to get more out of life. Even helped me with tuition. Now don't get me wrong, it was no picnic breaking out of my routine. But I guess if you want something bad enough it's up to you to take the first step. TCC just happened to make the next ones a whole lot easier. So now come 7:30, I'm still parked in front of a screen. Only this time it happens to be an IBM instead of a Magnavox.
TACOMA COMMUNITY COLLEGE
1 9 6 5 – 1 9 9 2

Well, we're at the bottom of the poster, so let's cut to the chase. We need your donation. To keep programs like this from becoming history. Because the way we see it, when you help others out, you help yourself. Call (206) 566-5003 or (206) 566-5005 and give Tacoma a hand. Thanks.

I USED TO THINK WHAT COULD BE WORSE. A single mother of three bringing home a paycheck that barely covered the basics. Rent. Bus fare. A day-old loaf of bread. Forget about toys for the kids or nice new clothes. Not this month. I never got past a high school education, and let me tell you, that doesn't carry a whole lot of weight these days. It reached the point when food stamps and handouts were no longer out of the question. I could barely hold onto the money I had, let alone my dignity. Not a day went by that I didn't wonder what could have been. Or what kind of life I was making for my kids. Sometimes on my way home from work, I'd wander around the college campus by our apartment, usually pretending to be a student. Yeah, right. One day I even went so far as to pick up a catalog. You know, play out the fantasy to the hilt. I thumbed through it, thinking I was some hot shot senior or something, when I came across this Spruce Program. Anyway, this program actually helps people like me get a real college education. And more out of life in the process. No more pretending. No more getting by on just the basics. No more day-to-day. Right then I decided to do it. It wasn't easy, but TCC made it possible with counseling, low-cost on-site child care and schedules that worked around mine. Hey, all I wanted was another chance. Now I can look back and see where I've been. And what I've become. A success. With a promising future and a renewed sense of pride in who I am. What could be better.
TACOMA COMMUNITY COLLEGE
1 9 6 5 – 1 9 9 2

Well, we're at the bottom of the poster, so let's cut to the chase. We need your donation. To keep programs like this from becoming history. Because the way we see it, when you help others out, you help yourself. Call (206) 566-5003 or (206) 566-5005 and give Tacoma a hand. Thanks.

Written by John F. Walter
from a story created by
Joseph Savage and
John F. Walter
Directed by
Thomas Schulz
Starring Joseph Savage and
John F. Walter

Opens February 28
Running March 1,2,3,7,8,
9,10,14,15 & 16
Somar Theatre
8th & Brannan
*When a father refuses to hit
bottom, his sons
must do it for him.*

Poster for a play.

DESIGN FIRM: Petrick

Design, Chicago, Illinois

ART DIRECTOR/

DESIGNER: Robert Petrick

Computer software
packaging.
DESIGN FIRM: Richards &
Swensen, Inc., Salt Lake
City, Utah

ART DIRECTOR/
DESIGNER: William
Swensen
COMPUTER PRODUCTION:
Deb Barfield

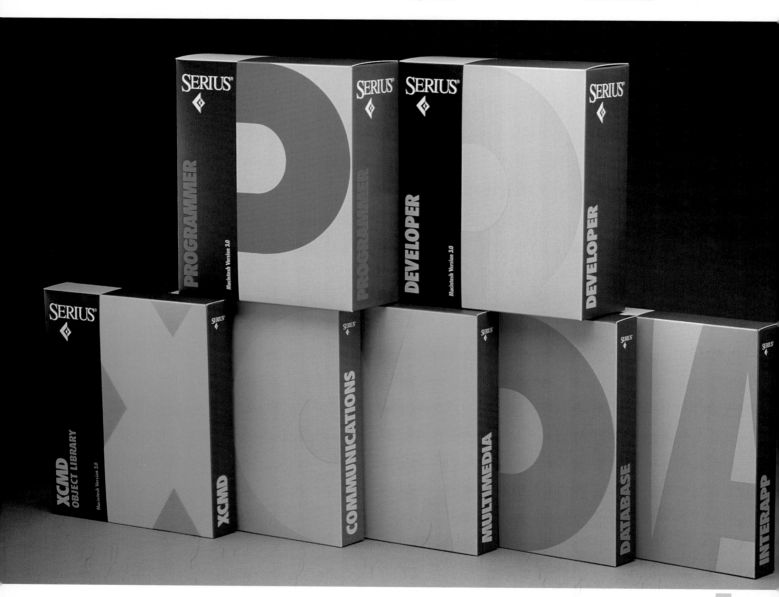

Invitation to the state agency's annual awards program.
DESIGN FIRM: Peter Good Graphic Design, Chester, Connecticut
ART DIRECTOR/
DESIGNER: Peter Good
TYPOGRAPHY: Kimset

CONNECTICUT ARTS AWARDS 1991

COLLABORATION

Spreads from VarBusiness.

DESIGN DIRECTOR: Joe

McNiell/CMP Publications-

VarBusiness Magazine,

Manhasset, New York

ART DIRECTOR: David

Loewy

ASSOCIATE

ART DIRECTOR: Renee

Bundi

DESIGNER: Andrea Pinto

ILLUSTRATORS: Paul

Rodgers (Copyright Laws),

Lou Beach (Smart

Software)

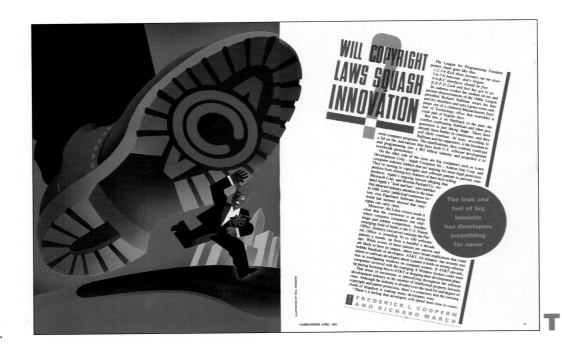

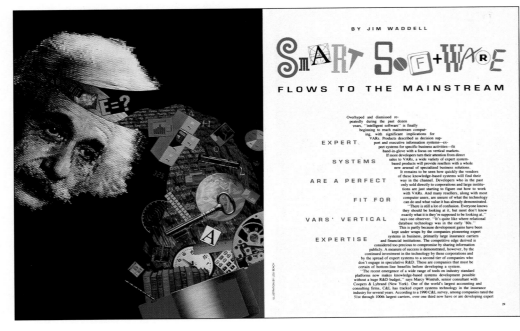

Newspaper delivery trucks.

DESIGN FIRM: Graham

Spencer, Rockford, Illinois

ART DIRECTORS/

DESIGNERS: Scott Spencer,

Jay Graham

PHOTOGRAPHER: KC

Keefer

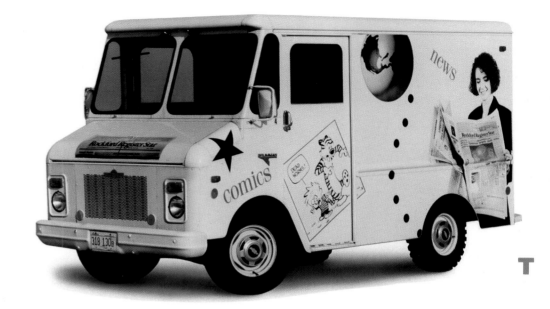

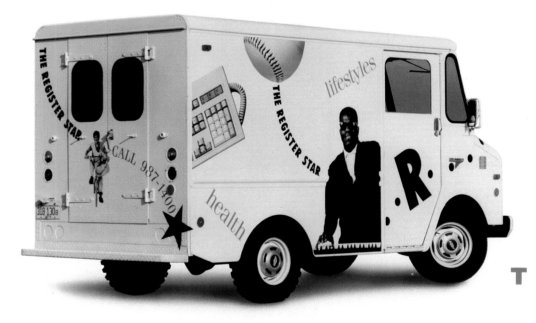

Book cover.

DESIGN FIRM: Louise Fili

Ltd., New York, New York

ART DIRECTOR: Frank

Metz (Simon & Schuster)

DESIGNER: Louise Fili

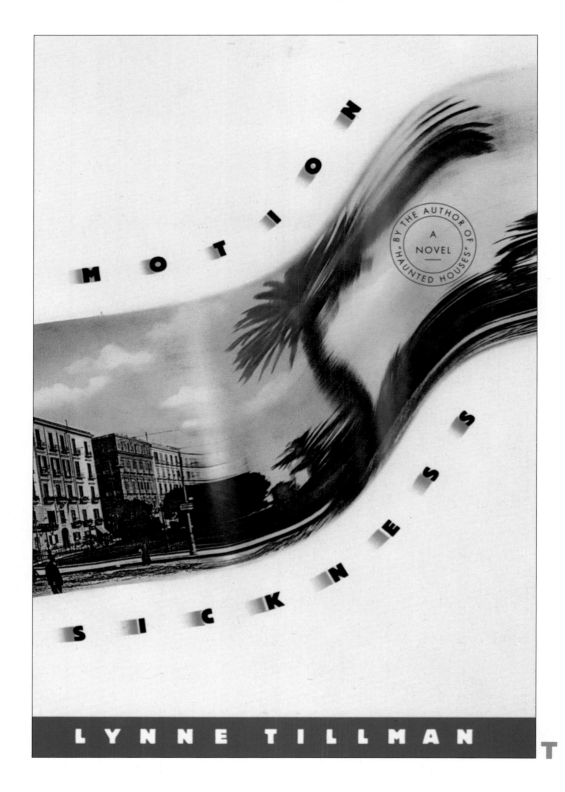

Fine art print for sale.

DESIGN FIRM: Michael

David Brown, Inc.,

Rockville, Maryland

ART DIRECTOR/

DESIGNER/ILLUSTRATOR:

Michael David Brown

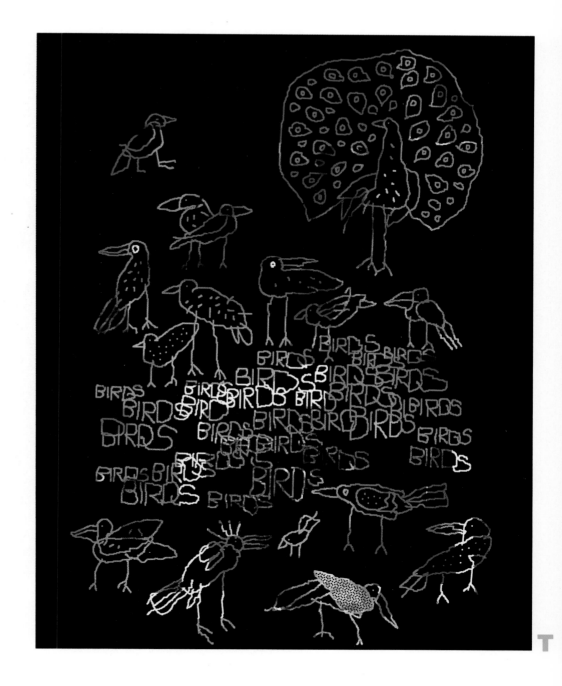

Fashion ad campaign.

DESIGN FIRM:

Goldsmith/Jeffrey, New

York, New York

ART DIRECTOR: Gary

Goldsmith

COPYWRITER: Ty

Montague

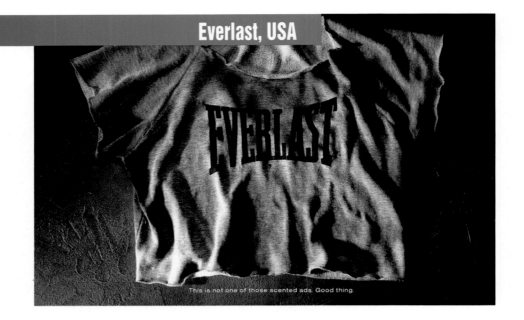

This is not one of those scented ads. Good thing.

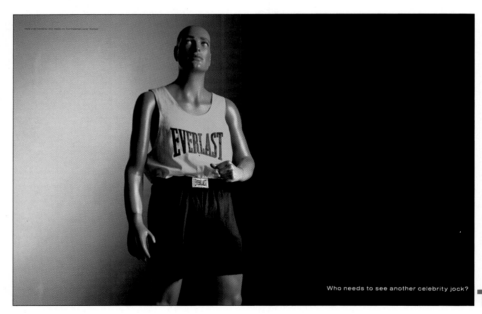

Who needs to see another celebrity jock?

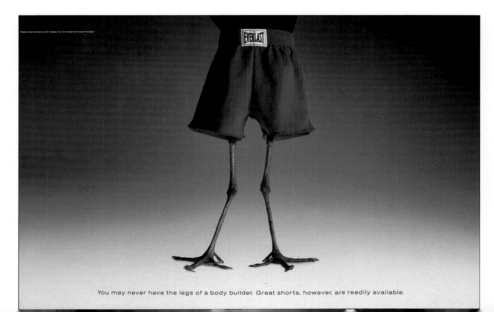

You may never have the legs of a body builder. Great shorts, however, are readily available.

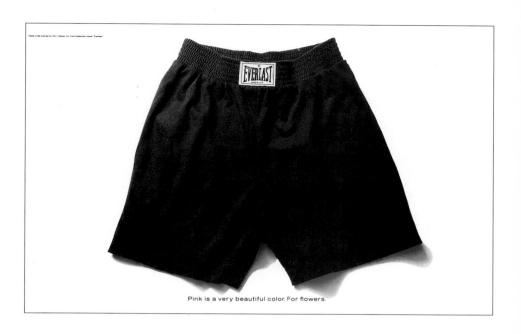

Pink is a very beautiful color. For flowers.

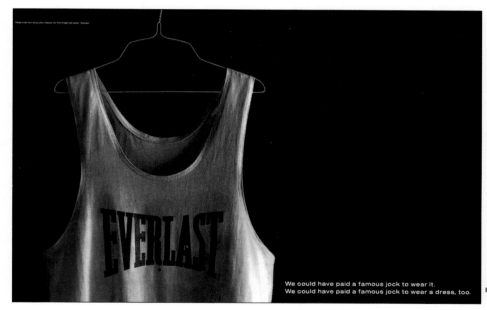

We could have paid a famous jock to wear it.
We could have paid a famous jock to wear a dress, too.

T

75

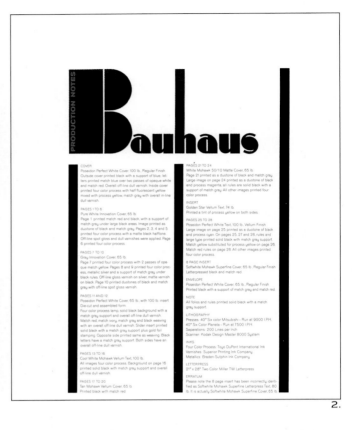

Cover (1), production notes insert (2), and inside spreads (3, 4) from No. 7 in a promotional series.

DESIGN FIRM: The Pushpin Group, Inc., New York, New York

ART DIRECTOR: Seymour Chwast

DESIGNERS: Seymour Chwast, Roxanne Slimak

EDITOR: Steven Heller

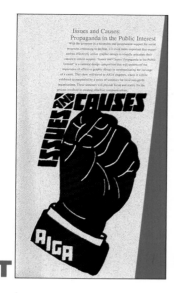

T

Fold-out call-for-entries.

DESIGN FIRM: The Pushpin Group, Inc., New York, New York

ART DIRECTOR/ DESIGNER/ILLUSTRATOR: Seymour Chwast

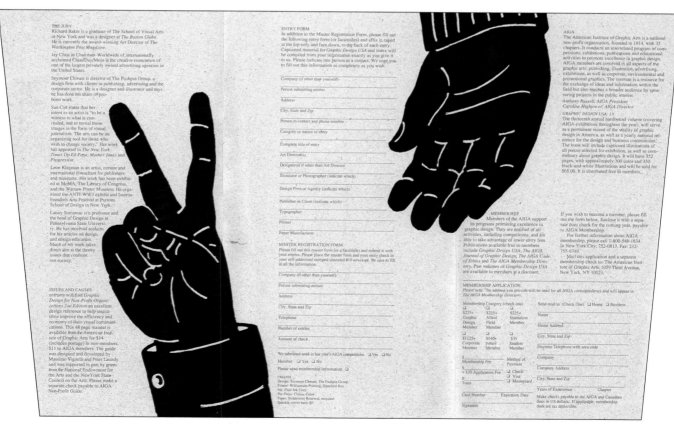

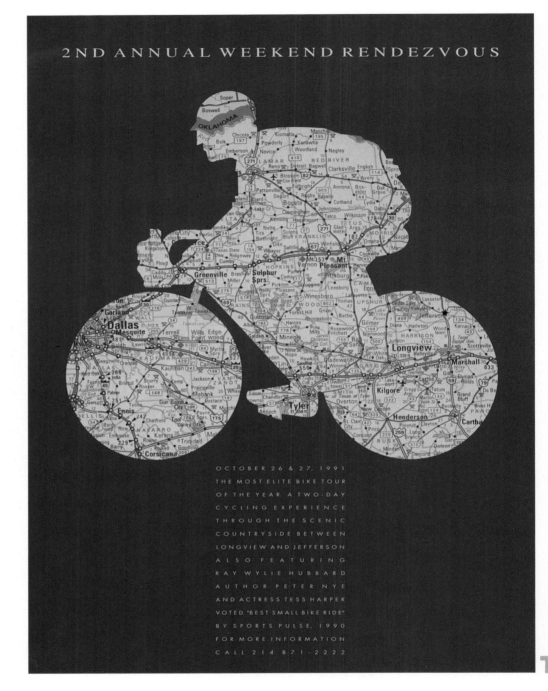

Poster promoting cycling
tour through Texas
countryside.
DESIGN FIRM: Brainstorm,
Inc. , Dallas, Texas
ART DIRECTOR/
DESIGNER/ILLUSTRATOR:
Ken Koester

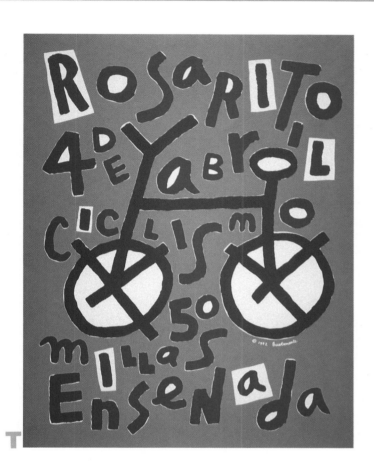

Poster and T-shirt promoting semi-annual "fun" bike ride in Baja, Caliornia.

DESIGN FIRM: Studio Bustamante, San Diego, California

DESIGNER/ILLUSTRATOR: Gerald Bustamante

PRINTER: Gordon Screen Print

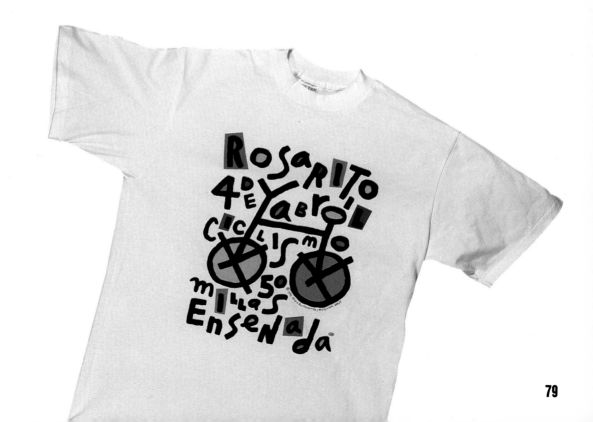

Spread from alumni

association magazine.

DESIGN FIRM: Peterson &

Company, Dallas, Texas

ART DIRECTOR/

DESIGNER: Scott Ray

ILLUSTRATOR: Keith

Graves

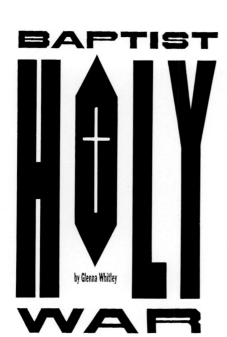

BAPTIST HOLY WAR

by Glenna Whitley

Paige Patterson is leading the fundamentalists' fight to save the Baptist Church from the "liberals." Will he destroy the denomination to purify it?

WHEN SHE SAW THE MARQUEE OUTSIDE FIRST BAPTIST CHURCH THAT MORNING, SU'ZI PANG HAD A flash. Since coming to work as a special assistant to Dr. Paige Patterson in 1988, the young woman had had a long-running battle with her boss—a contest to see who could pull the funniest practical jokes.

It had started simply enough. When Patterson discovered his assistant's phobia about animal skin, he made a point of taunting her with his cowboy boots—made of eel, ostrich, or snakeskin. The boots always

60 JANUARY 1991

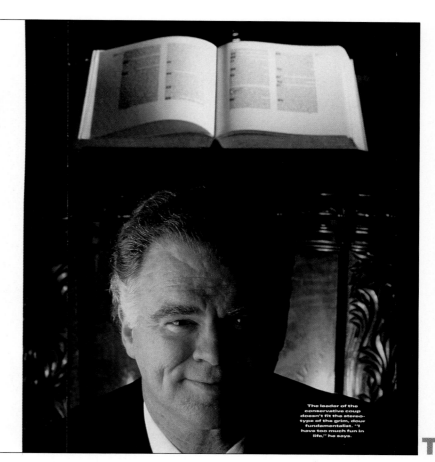

The leader of the conservative coup doesn't fit the stereotype of the grim, dour fundamentalist. "I have too much fun in life," he says.

Spread from city magazine

of Dallas.

DESIGNER: Liz Tindall/D

Magazine, Dallas, Texas

PHOTOGRAPHER: Doug

Milner

Covers and inside spreads
from Here & Now, a health
curriculum magazine aimed
at fourth- through ninth-
grade levels.
DESIGN FIRM: Hornall
Anderson Design Works,
Seattle, Washington
ART DIRECTOR: John
Hornall
DESIGNERS: Julia LaPine,
Heidi Hatelstad, David
Bates, Lian Ng

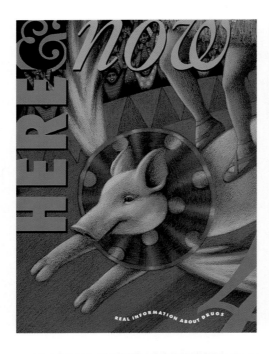

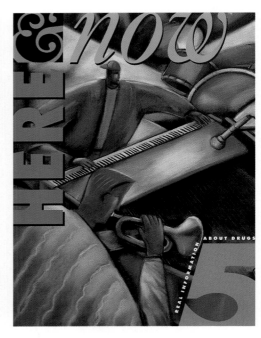

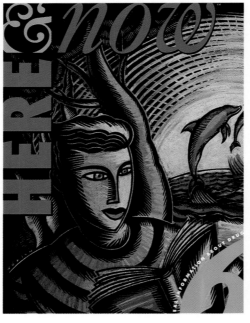

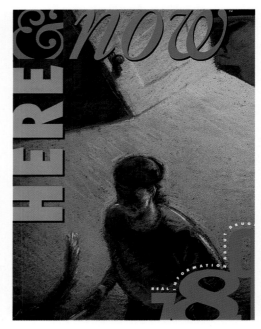

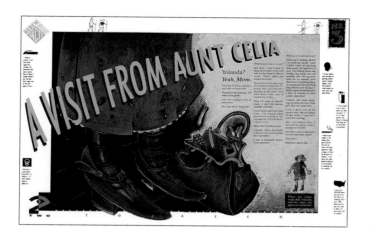

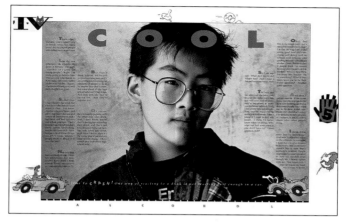

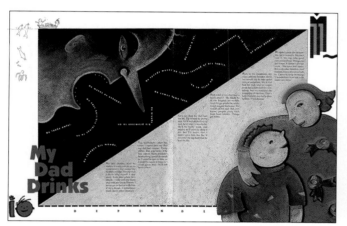

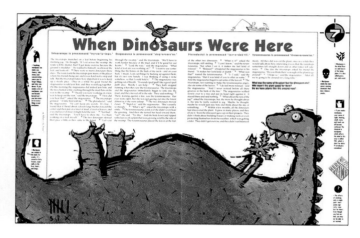

Giveaway poster promoting

opening of upscale

restaurant.

DESIGN FIRM: Rigsby

Design, Inc., Houston,

Texas

ART DIRECTOR/

DESIGNER/ILLUSTRATOR:

Lana Rigsby

Poster series designed to convey various messages in anti-drug curriculum for schoolchildren.

DESIGN FIRM: Hornall Anderson Design Works, Seattle, Washington

ART DIRECTOR: John Hornall

DESIGNER: Julia LaPine, Heidi Hatelstad, David Bates, Brian O'Neill

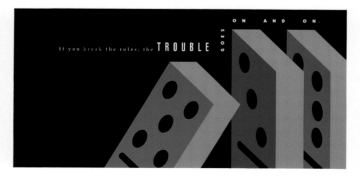

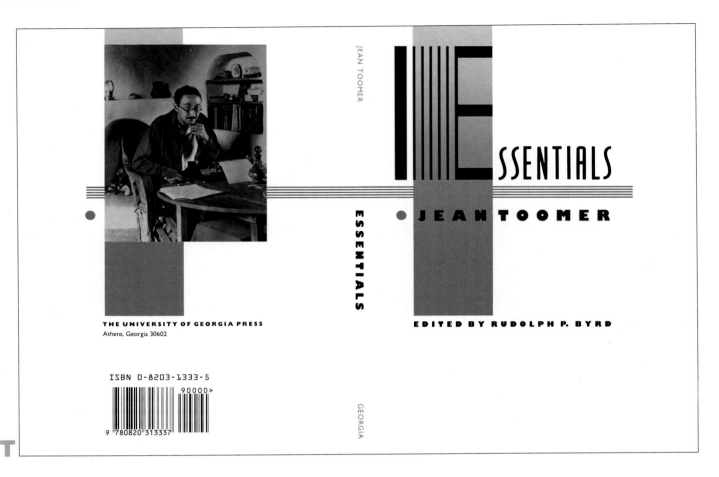

JEAN TOOMER

Essentials

ESSENTIALS

JEAN TOOMER

THE UNIVERSITY OF GEORGIA PRESS
Athens, Georgia 30602

EDITED BY RUDOLPH P. BYRD

ESSENTIALS

GEORGIA

ISBN 0-8203-1333-5

90000>

9 780820 313337

Book cover.

DESIGNER: Erin Kirk/

The University of Georgia

Press, Athens, Georgia

Book cover.

DESIGNER: Richard Hendel/

The University of North

Carolina Press, Chapel Hill,

North Carolina

LAST YEAR, THE READERS OF **US** AND *Rolling Stone* SPENT 734 MILLION DOLLARS ON ENTERTAINMENT. AND THAT DOESN'T EVEN INCLUDE POPCORN.

Advertisers who buy matching space in both US and Rolling Stone will receive a 15% discount in both publications. For details call Mr. Leslie Zeifman at (212) 484-1495.

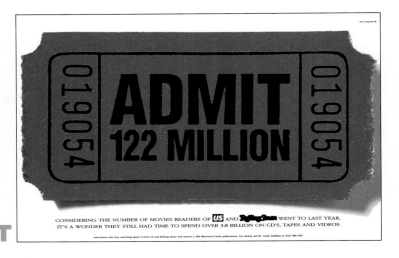

CONSIDERING THE NUMBER OF MOVIES READERS OF **US** AND *Rolling Stone* WENT TO LAST YEAR, IT'S A WONDER THEY STILL HAD TIME TO SPEND OVER 3.8 BILLION ON CD'S, TAPES AND VIDEOS.

Advertisers who buy matching space in both US and Rolling Stone will receive a 15% discount in both publications. For details call Mr. Leslie Zeifman at (212) 484-1495.

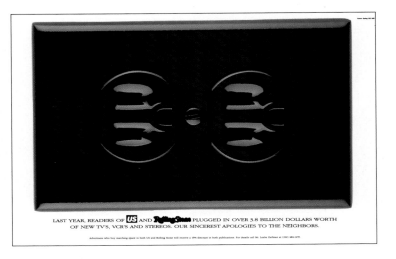

LAST YEAR, READERS OF **US** AND *Rolling Stone* PLUGGED IN OVER 3.8 BILLION DOLLARS WORTH OF NEW TV'S, VCR'S AND STEREOS. OUR SINCEREST APOLOGIES TO THE NEIGHBORS.

Advertisers who buy matching space in both US and Rolling Stone will receive a 15% discount in both publications. For details call Mr. Leslie Zeifman at (212) 484-1495.

Joint ad campaign.

AGENCY:

Goldsmith/Jeffrey,

New York, New York

ART DIRECTOR:

Gary Goldsmith

COPYWRITER:

Ty Montague

1.

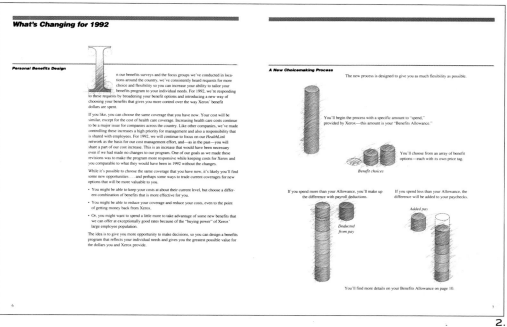

What's Changing for 1992

Personal Benefits Design

In our benefits surveys and the focus groups we've conducted in locations around the country, we've consistently heard requests for more choice and flexibility so you can increase your ability to tailor your benefits program to your individual needs. For 1992, we're responding to these requests by broadening your benefit options and introducing a new way of choosing your benefits that gives you more control over the way Xerox' benefit dollars are spent.

If you like, you can choose the same coverage that you have now. Your cost will be similar, except for the cost of health care coverage. Increasing health care costs continue to be a major issue for companies across the country. Like other companies, we've made controlling these increases a high priority for management and also a responsibility that is shared with employees. For 1992, we will continue to focus on our *HealthLink* network as the basis for our cost management effort, and—as in the past—you will share a part of our cost increase. This is an increase that would have been necessary even if we had made no changes to our program. One of our goals as we made these revisions was to make the program more responsive while keeping costs for Xerox and you comparable to what they would have been in 1992 without the changes.

While it's possible to choose the same coverage that you have now, it's likely you'll find some new opportunities . . . and perhaps some ways to trade current coverages for new options that will be more valuable to you.

• You might be able to keep your costs at about their current level, but choose a different combination of benefits that is more effective for you.

• You might be able to reduce your coverage and reduce your costs, even to the point of getting money back from Xerox.

• Or, you might want to spend a little more to take advantage of some new benefits that we can offer at exceptionally good rates because of the "buying power" of Xerox' large employee population.

The idea is to give you more opportunity to make decisions, so you can design a benefits program that reflects your individual needs and gives you the greatest possible value for the dollars you and Xerox provide.

A New Choicemaking Process

The new process is designed to give you as much flexibility as possible.

You'll begin the process with a specific amount to "spend," provided by Xerox—this amount is your "Benefits Allowance."

You'll choose from an array of benefit options—each with its own price tag.

Benefit choices

If you spend more than your Allowance, you'll make up the difference with payroll deductions.

If you spend less than your Allowance, the difference will be added to your paychecks.

Added pay

Deducted from pay

You'll find more details on your Benefits Allowance on page 10.

6 7

2.

3.

4.

5.

Cover of Personal Benefits Program folder (1), and covers (3-5) and spread (2) from interior brochures.
DESIGN FIRM:
Tom Fowler, Inc.,
Stamford, Connecticut
ART DIRECTOR/
DESIGNER:
Karl S. Maruyama
PHOTOGRAPHER:
Michael Heintz
ILLUSTRATOR:
Sandy Vaccaro

FICTION

SHIP FULL OF JEWS

Cristoforo
could hear
the moaning
from steerage, the
Chasids were chant-
ing again, moaning and
raving in their strange and
steeped tongue, the sounds of
the Hebrew emerging cloudily
from the deck of the *Pinta*, filling him
with some mixture of dread and regard, religiosity and hope, the swells and pitching of the
barren seas reminding him of the essential perilousness of his journey. Images of spices, fra-
grant bouquets from the sullen and mysterious East rose in his nostrils, taunting thoughts of the
new and deadly continent opening up before him possessed him with a kind of graciousness. The
sounds of the Chasids were overwhelming. Sometimes they would pray for hours, unstopping,
one choir beginning when another paused, filling the moist air with imprecations and song, at
other times they were silent, pitching and rolling in the deck, the queasiness of their condi-
tion doubtless the origin of this strange and necessary silence. Cristoforo did not under-
stand any of it. ✿ Of course the Chasids were not to understand, they were to trans-
port. Isabella had pointed this out to him. "They are none of your concern," she
had said. "They are being deported, will keep to themselves under guard, will
pray and rave in their strange way but have nothing to do with your journey."
The excitable Queen had gazed at him, her eyes full and penetrating in the
darkness. There was something very special between her and Cristoforo;
that had been his intimation from the start but of course under Ferdinand's cru-
el gaze and with the happenstance of the Inquisition, it was impossible to bring
this strange and stunned accord to any kind of realization. Cristoforo was a man of
his time, his mind was seized by the fragrance of spices, dreams of India, dreams of
fervent Indians clustering about him, proffering their strange and wistful aphrodisiacs, their
eyes round with promise. But with all of that, with thoughts of aphrodisiacs and Indians, his
imagination soared clear and pristine beyond this, somewhere far beyond fantasy. He had an
assignment; the Chasids were only the most marginal part of this. Standing on the deck, swaying,
finding purchase on the thin and decaying boards of this wretched ship which was, his great
friend Isabella had insisted, the very best available, Cristoforo pondered his fate, considered
his condition, swung keen and penetrating gaze toward India, the New World, the mysteri-
ous aphrodisiac land tucked beyond
the dip of the great horizon. *San-*
ta Maria, Cristoforo murmured
and did not know if he was
invoking that mother of
passage or repeating
the name of his
third and most
eccentric ship,
filled with

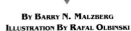

BY BARRY N. MALZBERG
ILLUSTRATION BY RAFAL OLBINSKI

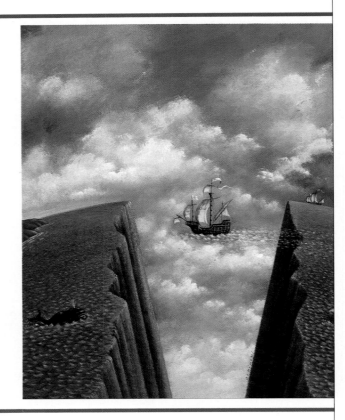

Fiction spread.

ART DIRECTOR:

Dwayne Flinchum/Omni

Magazine, New York,

New York

DESIGNERS:

Dwayne Flinchum,

Cathryn Bongiorno

ILLUSTRATOR:

Rafal Olbinski

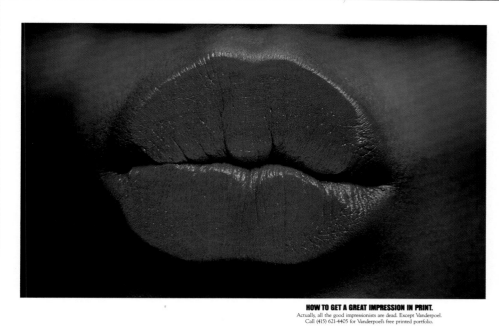

HOW TO GET A GREAT IMPRESSION IN PRINT.
Actually, all the good impressionists are dead. Except Vanderpoel.
Call (415) 621-4405 for Vanderpoel's free printed portfolio.

Ad campaign.

AGENCY: Anderson &

Lembke, Inc., San Francisco,

California

ART DIRECTOR: Tom Roth

COPYWRITER:

Mark Ledermann

PHOTOGRAPHER:

Fred Vanderpoel

HOW TO IGNORE THE BRAIN.
Listen to your eyes. Call (415) 621-4405 for Vanderpoel's free printed portfolio.

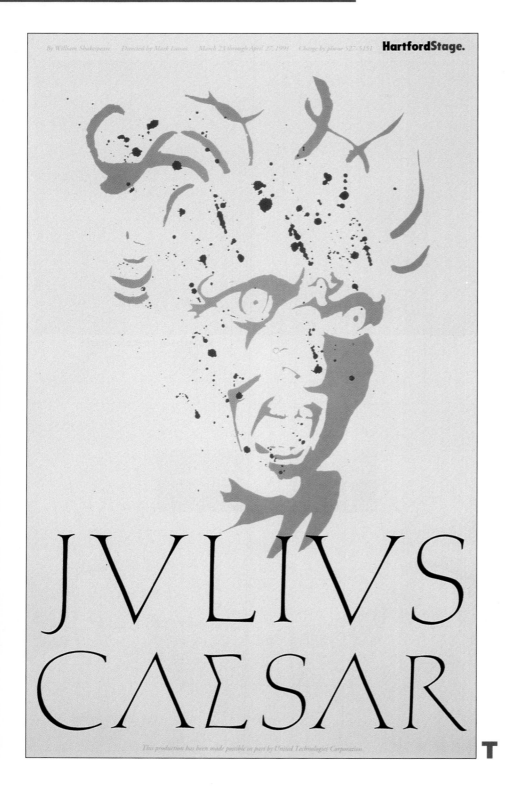

Poster for production of Shakespeare's play, *Julius Caesar*.

DESIGN FIRM: Wondriska Associates, Farmington, Connecticut

ART DIRECTOR: William Wondriska

DESIGNER/ ILLUSTRATOR: Christopher Passehl

PRINTER: W.E. Andrews

Program and booklet for a

benefit evening for the

Public Theater.

DESIGN FIRM:

Paul Davis Studio,

New York, New York

ART DIRECTOR/

ILLUSTRATOR: Paul Davis

DESIGNERS: Paul Davis,

Mariana Ochs

Book covers.

ART DIRECTORS/

DESIGNERS: Jim Wageman
(Spike Lee), Rita Marshall
(Chocolate)/Stewart,
Tabori & Chang, New York,
New York

PHOTOGRAPHERS:
David Lee (Spike Lee),
Martin Jacobs (Chocolate)

THE
INTERNATIONAL
CHOCOLATE
COOKBOOK

Photographs by
MARTIN JACOBS
NANCY BAGGETT

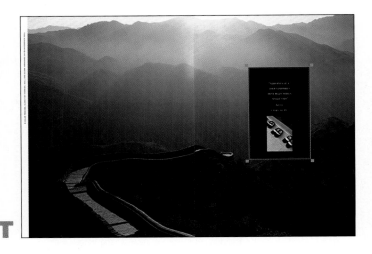

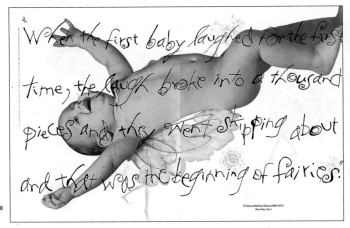

Spreads from "Begin at the Beginning" paper promotion.

DESIGN FIRM:
The Kuester Group, Minneapolis, Minnesota

ART DIRECTORS:
Kevin B. Kuester, Brent Marmo

DESIGNER: Brent Marmo

COPYWRITER: David Forney

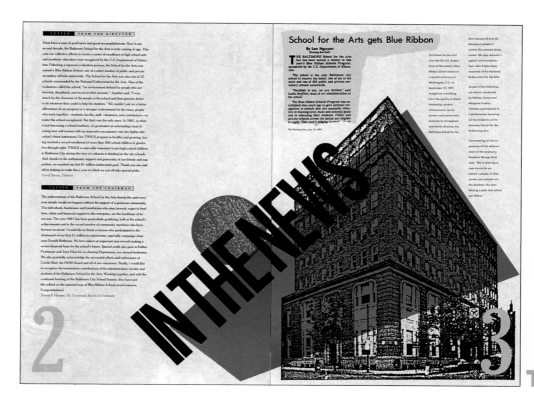

Cover and spreads from report on fundraising activities and goals.

DESIGN FIRM:

Martin Bennett Design, Baltimore, Maryland

ART DIRECTOR/ DESIGNER: Martin Bennett

COPYWRITER:

Cynthia Glover

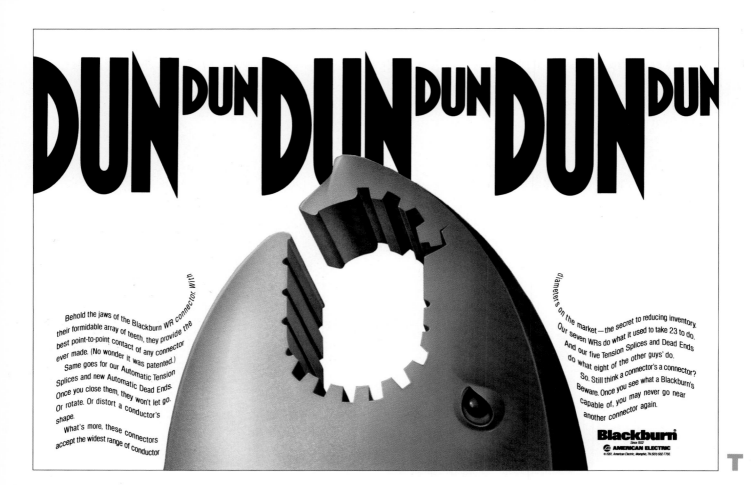

Ad for a wire connector.

AGENCY: Thompson & Company, Memphis, Tennessee

CREATIVE DIRECTOR:

Michael H. Thompson

ART DIRECTOR:

Trace Hallowell

COPYWRITER:

Sheperd Simmons

ILLUSTRATOR:

Theo Rudnak

TYPOGRAPHY: Great Faces

Sales promotion postcards used by the public relations department.

DESIGN FIRM:

Shankweiler/Sealy Design, Inc., New Haven, Connecticut

ART DIRECTORS/ DESIGNERS:

Linda Shankweiler, Gerard Sealy

Shipping company's 1992 calendar, with a theme of "Connecting the World."

DESIGN FIRM:

Morla Design, Inc.,

San Francisco, California

ART DIRECTOR:

Jennifer Morla

DESIGNERS:

Jennifer Morla,

Sharrie Brooks

COPYWRITER:

Stefanie Marlis

PHOTOGRAPHER:

Henrik Kam

Joint self-promotional
calendar.
DESIGN FIRM:
Wish You Were Here,
San Francisco, California

ART DIRECTOR/
DESIGNER: Bobbi Long
PHOTOGRAPHER:
Joanie Yokom

PAUL, WEISS, RIFKIND
WHARTON & GARRISON

Cover and inside spreads from law firm's brochure.

DESIGN FIRM:

The Pushpin Group, Inc.,
New York, New York

ART DIRECTOR:

Seymour Chwast

DESIGNER: Roxanne Slimak

Two Part Harmony art
exhibit promotional mailer
which unfolds to a poster.
DESIGN FIRM:
Sam Smidt, Inc., Palo Alto,
California
ART DIRECTOR/
DESIGNER: Sam Smidt

woof!

MODERN
M

(thank you!)

1.

Thank You

from Modern Dog

2.

Thank You

from the bottom of our ♥'s

3.

DESIGN

THAT MAKES YOU

SIT UP

AND BEG.

MODERN DOG DESIGN

MCMXCII

4.

Self-promotional postcard series.

DESIGN FIRM: Modern Dog, Seattle, Washington

ART DIRECTORS:

Michael Strassburger, Robynne Raye, Vittorio Costarella

DESIGNERS:

Vittorio Costarella (1),

Michael Strassburger (2,4),

Robynne Raye (3)

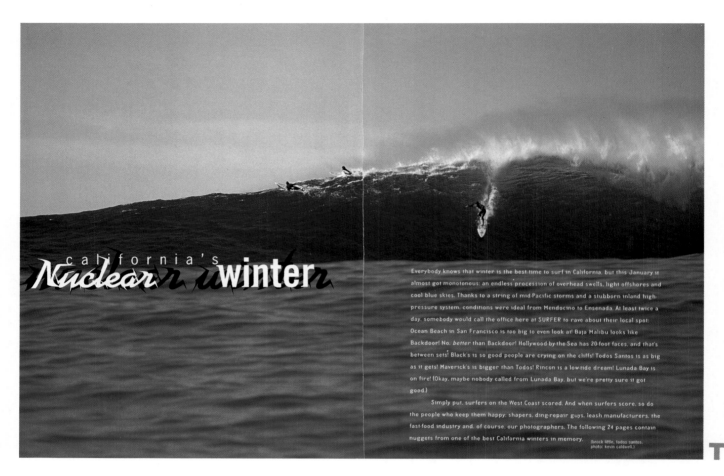

california's
Nuclear **winter**

Everybody knows that winter is the best time to surf in California, but this January it almost got monotonous: an endless procession of overhead swells, light offshores and cool blue skies. Thanks to a string of mid-Pacific storms and a stubborn inland high-pressure system, conditions were ideal from Mendocino to Ensenada. At least twice a day, somebody would call the office here at SURFER to rave about their local spot: Ocean Beach in San Francisco is too big to even look at! Baja Malibu looks like Backdoor! No, *better* than Backdoor! Hollywood-by-the-Sea has 20-foot faces, and that's between sets! Black's is so good people are crying on the cliffs! Todos Santos is as big as it gets! Maverick's is bigger than Todos! Rincon is a low-tide dream! Lunada Bay is on fire! (Okay, maybe nobody called from Lunada Bay, but we're pretty sure it got good.)

Simply put, surfers on the West Coast scored. And when surfers score, so do the people who keep them happy: shapers, ding-repair guys, leash manufacturers, the fast-food industry and, of course, our photographers. The following 24 pages contain nuggets from one of the best California winters in memory.

(brock little, todos santos. photo: kevin caldwell.)

Opener spreads.

DESIGN FIRM: David Carson Design, Del Mar, California

ART DIRECTOR/
DESIGNER: David Carson

PHOTOGRAPHERS:

Kevin Caldwell (Nuclear Winter), Don Montgomery (Cold Sweat)

TYPOGRAPHERS:

Lisa Vorhees, Richard Bates (Nuclear Winter)

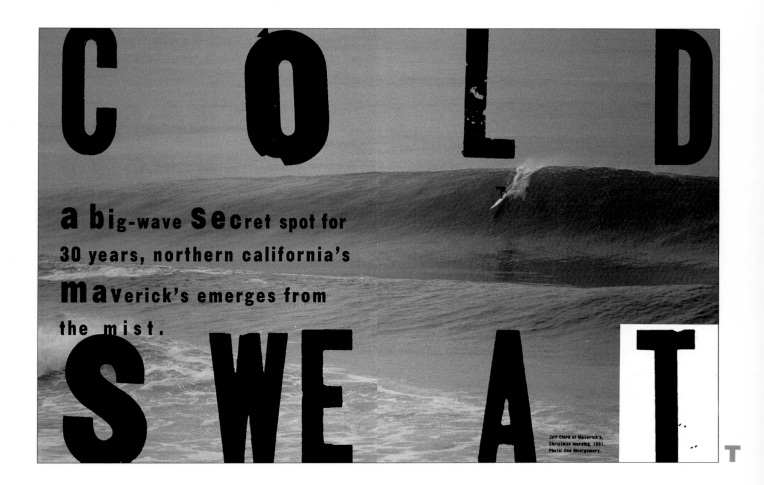

COLD SWEAT

a big-wave **se**cret spot for 30 years, northern california's **ma**verick's emerges from the mist.

Jeff Clark at Maverick's,
Christmas morning, 1991.
Photo: Don Montgomery.

Bus shelter ad.

DESIGN FIRM:

Midnight Oil Studios,

Boston, Massachusetts

AGENCY: Ogilvy & Mather

ART DIRECTOR:

Art Connelly

DESIGNERS: Kathryn Klein,

James Skiles

COPYWRITER:

Bruce Richter

PHOTOGRAPHER:

Nora Scarlett

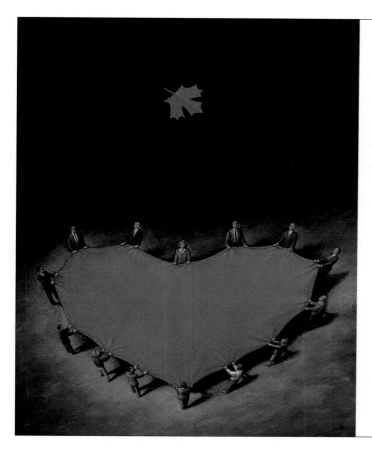

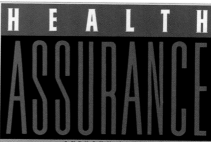

IN CANADA, A LITTLE PLASTIC CARD GETS YOU FREE CARE ANYWHERE. WHAT'S THE CATCH?

HEALTH
ASSURANCE

By ANTHONY SCHMITZ

THE LAST SNOW HAD MELTED JUST DAYS BEFORE, though the mountains towering over Vancouver were still blanketed. In the city flowers bloomed—crocuses, daffodils. A fresh breeze swept in from the Pacific, through the open windows of the heart ward at Vancouver General.

Six days after open heart surgery, Tom Berrie lay naked on his bed. A nurse bent over him, tugging at the glinting metal staples that held the sixty-three-year-old retiree together.

"I'll be done here in a minute," he said in a Scotsman's brogue that was surprisingly hale, considering the circumstances.

Berrie had every reason to be pleased. He'd gotten the operation he needed. He'd lived to tell about it. And thanks to Canada's health care system, he hadn't paid a cent. Still, there was one substantial hitch. Berrie had waited to get his surgery for the better part of a year. During those long months he wondered if this were a bargain that would kill him.

When the nurse finished, he rose and wrapped himself in a hospital gown. With his full head of hair and trim dark mustache, Berrie looked fit—so long as he stood still. When he moved it was with the caution of a man who feared he might fly apart.

A Scot by birth, Berrie left Glasgow for Canada with his wife and two children in the 1950s. "I came here because it was far away from Britain," he said. "Too far to turn back. Once I got here I had to make a go of it." In Burnaby, a Vancouver suburb, Berrie returned to law enforcement, the occupation he'd left behind in Scotland. He'd been retired for just ten months in January of 1989 when he suffered a heart attack while reading the morning

Illustrations by
RAFAL OLBINSKI ~ TOMEK OLBINSKI

JANUARY/FEBRUARY 1991 In HEALTH 39

Opener and spread.

ART DIRECTOR:

Jane Palecek/HEALTH

Magazine, San Francisco,

California

ILLUSTRATORS:

Rafal Olbinski, Tomek

Olbinski

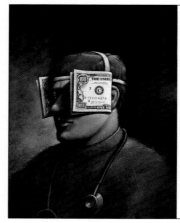

Self-promotional billboard ads in praise of outdoor advertising.
DESIGN FIRM:
Timothy G. Freed Design, York, Pennsylvania
ART DIRECTOR/
DESIGNER:
Timothy G. Freed

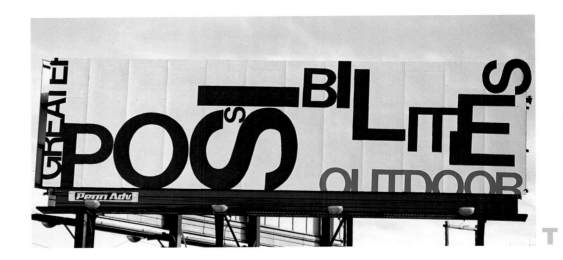

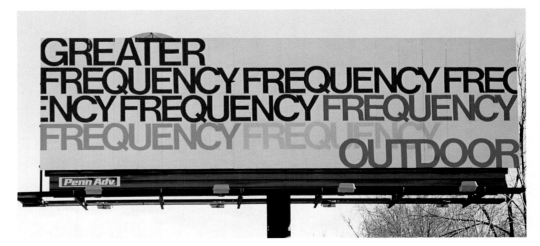

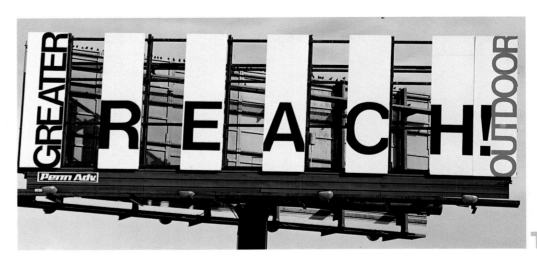

1.

Cover (1), interior spreads (2,3) and detail (4) from Inquirer magazine cover article.

ART DIRECTOR/
DESIGNER:
Jessica Helfand/Inquirer Magazine, Philadelphia, Pennsylvania

ILLUSTRATOR:
William Sloan

2.

3.

4.

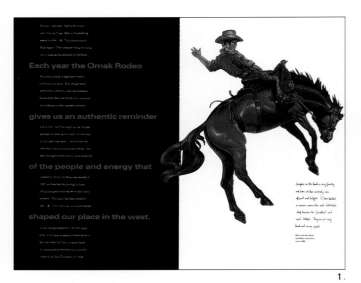

1.

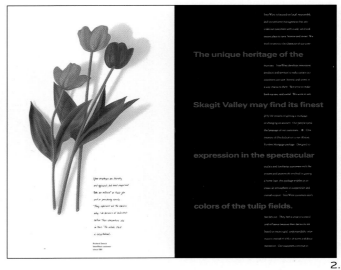

2.

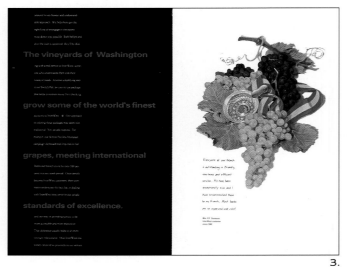

3.

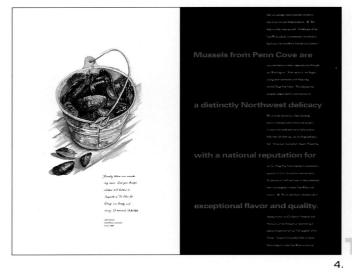

4.

Spreads from 1991 annual report.

DESIGN FIRM:
Leimer Cross Design, Seattle, Washington

ART DIRECTOR/ DESIGNER: Kerry Leimer

ILLUSTRATORS:
Chris Hopkins (1), Gary Jacobsen (2), Chuck Pyle (3), Bobbi Tull (4), Jonathan Combs (not shown)

Pages from 1992
promotional calendar.

DESIGN FIRM:
Design for Marketing,
San Francisco, California

ART DIRECTOR:
Jane Palecek

DESIGNER:
Paulette Traverso

ILLUSTRATORS:
Malcolm Tarlofsky (April),
Henrik Drescher (June)

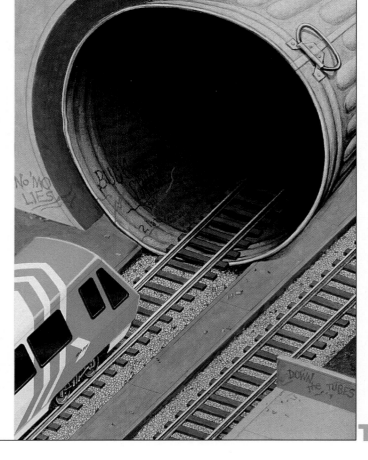

Opener spreads.

ART DIRECTOR:

Steve Connasster/

D Magazine, Dallas, Texas

DESIGN DIRECTOR:

Cynthia Eddy (DART
Doesn't Rule)

DESIGNER/

PHOTO EDITOR:

Liz Tindall (D.O.A.)

ILLUSTRATOR:

Steve Pietzch (DART
Doesn't Rule)

PHOTOGRAPHER:

David MacKenzie (D.O.A.)

D.O.A.

Your chances of receiving good medical care after a life-threatening accident are getting worse. Unless something is done soon, trauma care in Dallas could die.

BY ROD DAVIS

weather had just broken and a norther was dumping hard rain on rush-hour traffic when 75-year-old Giles Wilson* felt his chest go tight. He couldn't keep his pickup on the slick streets near Josey Lane in Carrollton and veered off sharply, brushing a utility pole before plowing into a tree. Carrollton EMS (Emergency Medical Services) responded in three minutes, but Wilson was unconscious with dangerously low blood

*The name has been changed at the request of the family.

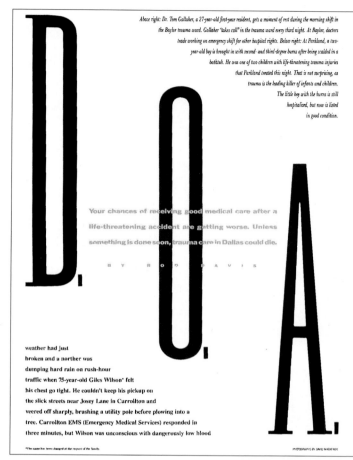

PHOTOGRAPHS BY DAVID MACKENSIE

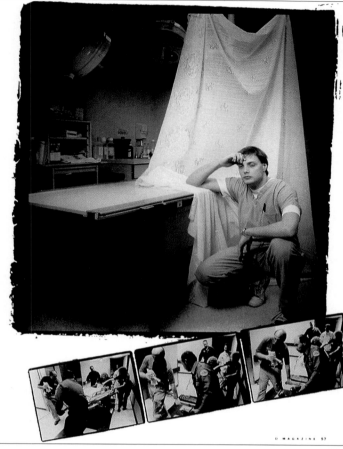

Above right: Dr. Tom Gallaher, a 27-year-old first-year resident, gets a moment of rest during the morning shift in the Baylor trauma ward. Gallaher "takes call" in the trauma ward every third night. At Baylor, doctors trade working on emergency shift for other hospital rights. Below right: At Parkland, a two-year-old boy is brought in with second- and third-degree burns after being scalded in a bathtub. He was one of two children with life-threatening trauma injuries that Parkland treated this night. That is not surprising, as trauma is the leading killer of infants and children. The little boy with the burns is still hospitalized, but now is listed in good condition.

D MAGAZINE 57

T

Cover and spreads from Designers Guide to Chicago, presented to attendees at AIGA national conference.

DESIGN FIRMS:

Kym Abrams Design/ Chicago, Illinois, Sam Silvio Design

ART DIRECTORS:

Kym Abrams, Sam Silvio

COPYWRITERS:

Lisa Brenner, Aaron Buchman

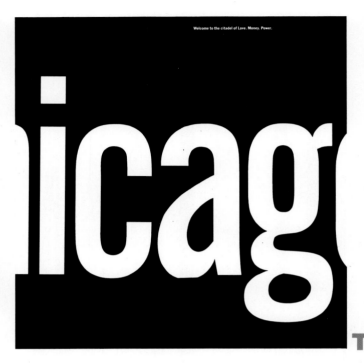

Welcome to the citadel of Love. Money. Power.

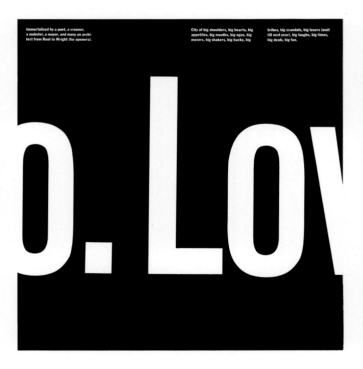

Immortalized by a poet, a crooner, a mobster, a mayor, and many an architect from Root to Wright (for openers).

City of big shoulders, big hearts, big appetites, big mouths, big egos, big movers, big shakers, big bucks, big bribes, big scandals, big losers (wait till next year), big laughs, big times, big deals, big fun.

Chiasso
700 North Michigan Avenue
642 2808

Modern designs for home and office.

1.

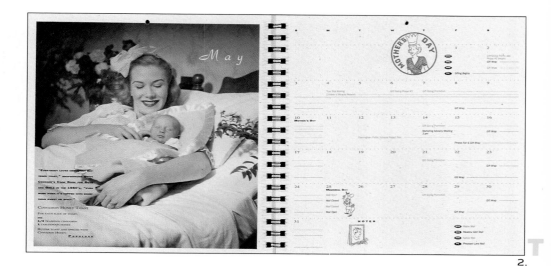

2.

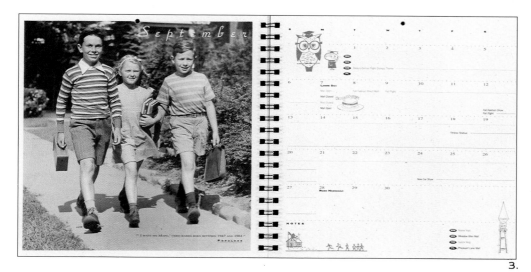

3.

Cover (1) of invitation to
annual merchants dinner.
Spreads (2,3) from events
calendar distributed at
dinner.

DESIGN FIRM:

Eymer Design, Boston,

Massachusetts

ART DIRECTOR:

Douglas Eymer

DESIGNERS: Selene Eymer,

David Ekizian

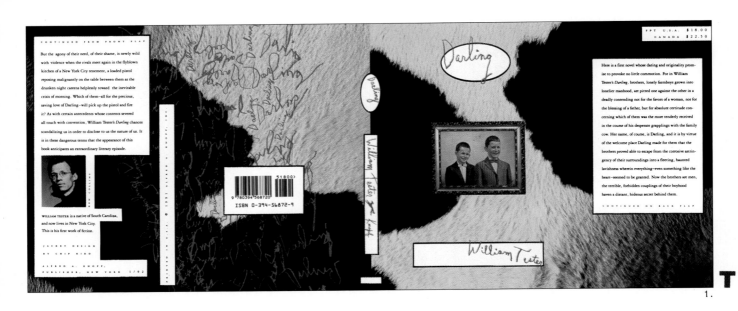

1.

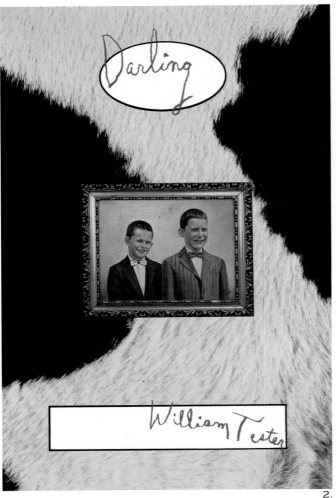

2.

Full book jacket (1) and

front cover (2).

ART DIRECTOR:

Carol Devine Carson/

Random House, New York,

New York

DESIGNER: Chip Kidd

Business card (1) and postcard promotion (2) for restored Checker cab available for rent as a media prop.

DESIGN FIRM:

Robert Padovano Design, Brooklyn, New York

ART DIRECTOR/

DESIGNER/ILLUSTRATOR:

Robert Padovano

1.

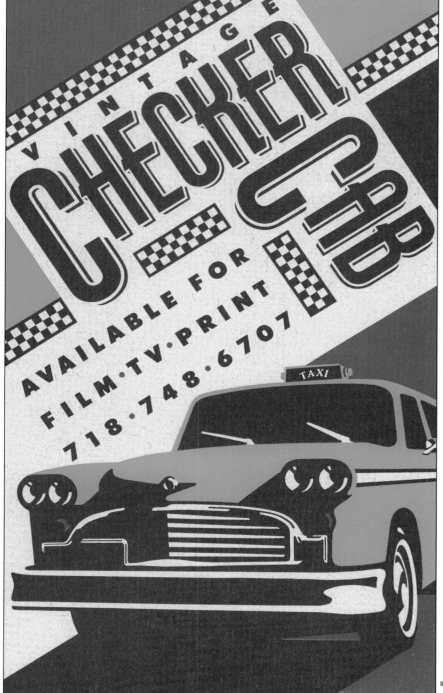

2.

See that little red thing there? We call it a Firing Pin™, and it picks up the line so your finger doesn't have to, which lets you cast faster and easier, but only when you pull the trigger on a Snapshot spinning reel. *Quantum* Snapshot™ *ZEBCO*

SE Series

EX Series

SLS Series

SS Series

Magazine ad.

PHOTOGRAPHER:

Marvy! Advertising

Photography, Hopkins,

Minnesota

AGENCY: Carmichael Lynch

ART DIRECTOR: Jim Keane

COPYWRITER: Joe Nagy

Leave-behind self-

promotion poster.

DESIGN FIRM:

Bates Design, Charleston,

South Carolina

ART DIRECTOR:

Chuck Bates

DESIGNER: Caitilin Lucey

COPYWRITER:

Nancy Smeltzer

PHOTOGRAPHER:

John Popiel

Ad campaign.

AGENCY: Ads Infinitum,

Minneapolis, Minnesota

ART DIRECTOR/

DESIGNER: Doug Trapp

COPYWRITER: Jean Rhode

PHOTOGRAPHER:

Steve Niedorf

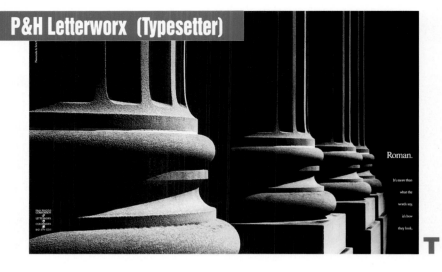

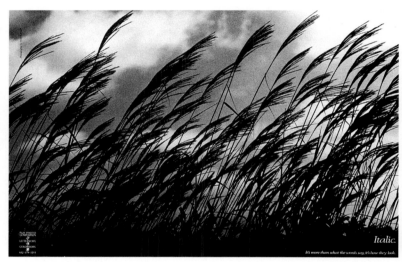

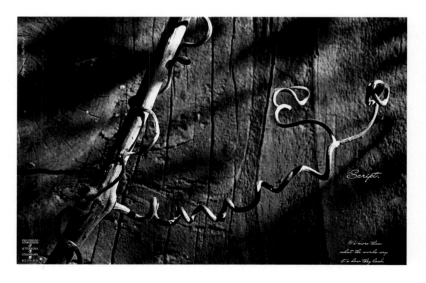

Cover and inside pages of promotional booklet about the problems of designing an annual report. Text is printed on a series of translucent sheets and what starts out as readable ends up as an unintelligible black blob.

DESIGN FIRM:

Liska and Associates, Inc., Chicago, Illinois

ART DIRECTOR:

Steve Liska

DESIGNER: Brock Haldeman

Promotional poster for
annual fundraising race.
AGENCY: Finnegan & Agee,
Inc., Richmond, Virginia
ART DIRECTOR:
Carlton Gunn

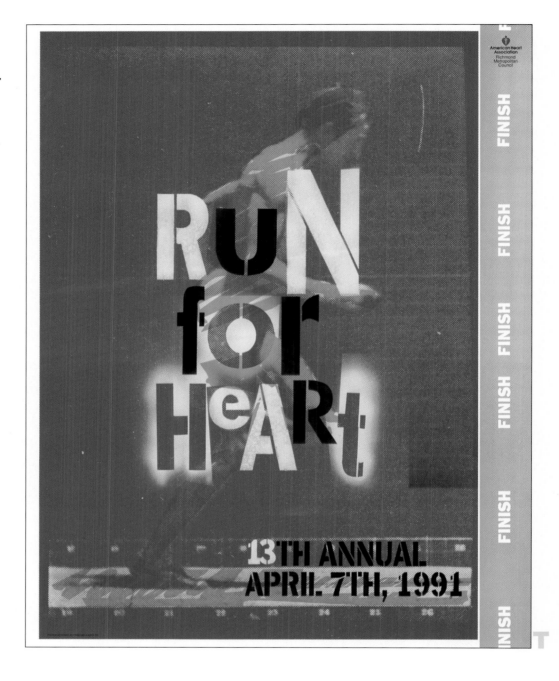

Poster (2) and brochure (1)
promoting second annual
Charleston Blues Festival.
DESIGN FIRM: Gil Shuler
Graphic Design, Inc.,
Charleston, South Carolina
ART DIRECTOR: Gil Shuler
DESIGNERS: Gil Shuler,
Laura Barroso
ILLUSTRATOR:
John Carroll Doyle

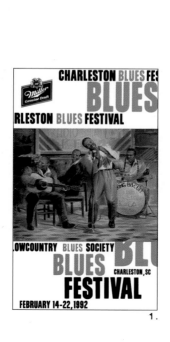

1.

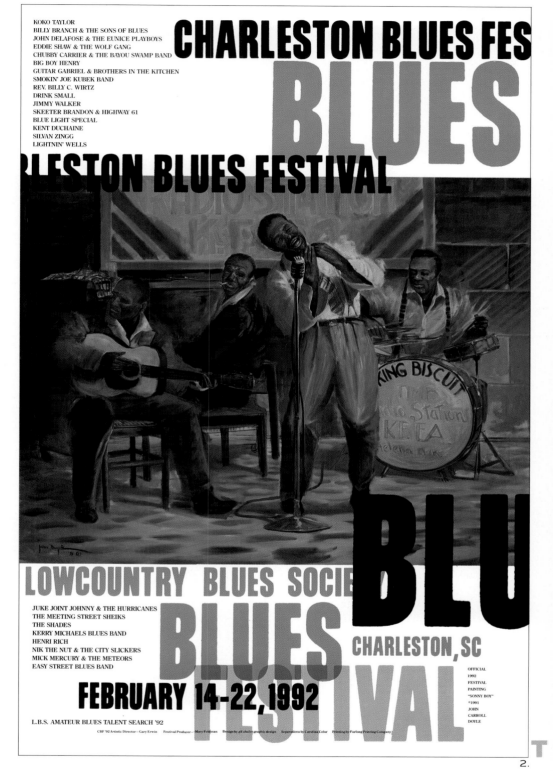

2.

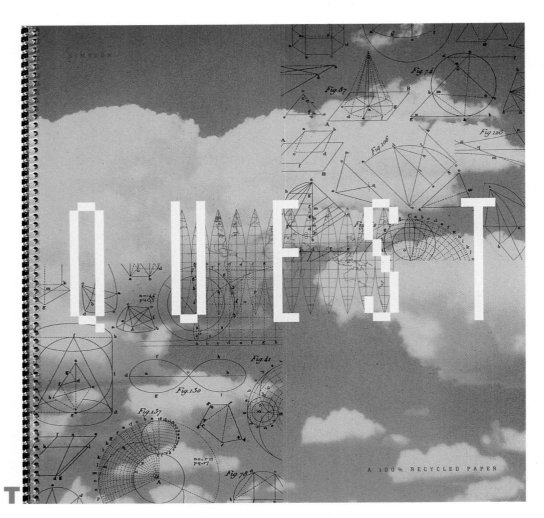

Cover and inside spread from promotional booklet introducing Quest 100% recycled paper.

DESIGN FIRM:

Pentagram Design, San Francisco, California

ART DIRECTOR: Kit Hinrichs

DESIGNER: Belle How

COPYWRITER:

Delphine Hirasuna

PHOTOGRAPHERS:

Geoff Kern, Barry Robinson, Charly Franklin

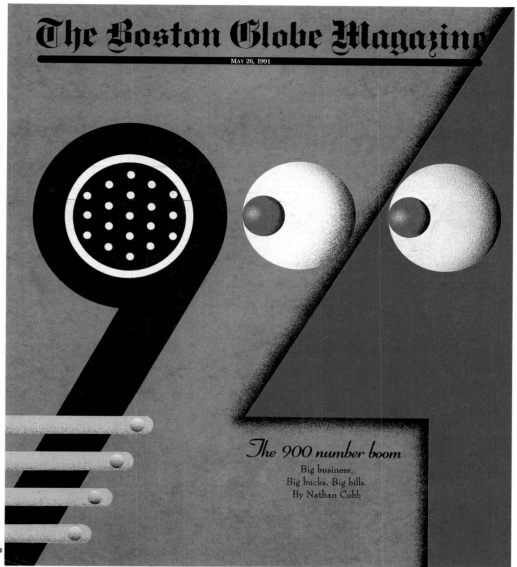

Cover and inside spread from story in The Boston Globe Magazine.

ART DIRECTOR/

DESIGNER:

Lucy Bartholomay/The

Boston Globe Magazine,

Boston, Massachusetts

ILLUSTRATOR: Terry Allen

Harrow Delight
Ripening a month before Bartlett, which is the standard in pears, Harrow Delight is highly blight resistant, about 9 on the scale. It replaces Clapp's Favorite, a popular older pear that ripens at the same time, approximately mid-August. Harrow Delight has a distinctive flavor, rated better than Clapp's and as good as Bartlett. The fruits are juicy, buttery and sweet, slightly smaller than those of Bartlett and yellow-green with a slight red blush. They keep 2-3 weeks. Harrow Delight was introduced in 1983 by the Harrow Research Station in Ontario.

Stark Honeysweet
This delicious pear, introduced in 1973 by Purdue University in Indiana, is an improved version of Seckel. It rates about an 8 on the blight-resistance scale. The fruit ripens in early September, a week after Bartlett. It's very creamy, soft, sweet and aromatic, reminiscent of Seckel (one of its parents). The skin is golden brown and slightly russeted. The fruit is smaller than most popular pears, but it's twice the size of Seckel. Unlike most other pears, this variety can set fruit without cross-pollination, but will sacrifice its size. Keeps 3-4 weeks.

Magness
Released by the USDA in 1960, Magness is one of the finest flavored of all pears and rates 9 on the disease-resistance scale. For this variety, blight seems to be mostly a problem on hail-damaged older wood. Its parents are Giant Seckel and Comice, two of the best-tasting pears ever. Magness ripens a week later than Bartlett but will keep in cold storage for up to three months. The fruit is medium in size, squat and round. The skin is an ochre-green and lightly russeted. The flesh is very soft, smooth and melting, and delightfully perfumed. Since Magness produces no viable pollen, you must plant it with two other varieties that will pollinate each other as well as Magness.

Harvest Queen
This 1983 introduction, also from the Harrow Station, ripens in late August, about a week before Bartlett. The flavor, texture and color of the fruit are said to be indistinguishable from Bartlett. The only differences are that the pears are about 10% smaller, and unlike Bartlett, which is very vulnerable to blight, the trees of Harvest Queen are highly blight resistant.

Harrow Sweet
The newest addition to the ranks of high-quality, fire blight-resistant pears — Harrow Sweet — was named in 1990. It's a sibling of Harrow Delight, but ripens much later, a full 3½ weeks after Bartlett. The fruit, yellow blushed with red, is about the size of Bartlett, and is reputed to be very sweet and juicy with an aromatic flavor all its own. The skin is tough and the flesh a bit gritty near the core. With ordinary refrigeration, Harrow Sweet will keep easily through December.

Starking Delicious
Also known as Maxine, this seedling variety of unknown parentage was found in Preble County, Ohio, around 1900. For more than 70 years it was the closest thing to a blight-resistant Bartlett that we had. The fruit ripens about a week after Bartlett, and has a similar size (if anything, it's slightly larger) and a bright yellow color. Unlike most European pears, this variety can be pleasant when the flesh is still slightly crisp, before it turns soft and buttery. This pear is sweet and juicy, but lacks the balance of acidity and aromatic qualities of Bartlett. On the blight scale, it rates a 7. Keeps 2-3 weeks.

Seckel
This old classic is the rarest of the rare: a chance American seedling, both highly blight resistant (8 on the scale) and of the highest quality. The reason it remains relatively obscure (unknown in supermarkets) is that the golden-brown fruit is smaller than a large plum, only about two inches in diameter. Most pears have coarse skin; Seckel's is very tender and holds much of the spicy flavor for which it is renowned. And Seckel is unusual among European pears in that some fruit can be left on the tree until it is close to fully soft. Other European pears must be picked when the green skin starts to lighten and the stem breaks readily from the fruit spur, then allowed to ripen indoors for seven to 10 days at room temperature. Seckel's flesh is buttery, highly sugared, aromatic and very juicy. Picked when ripe but still hard, then refrigerated immediately, it can be kept at top quality about two months, until mid-November.

Prominent **Pear**agraphs

PEAR: BOBBI ANGELL/ANDREW/GRANT URIE

Spread and page from article on pears.

ART DIRECTOR/ DESIGNER: Linda Provost/ National Gardening Magazine, Burlington, Vermont

ILLUSTRATORS: Bobbi Angell, Grant Urie

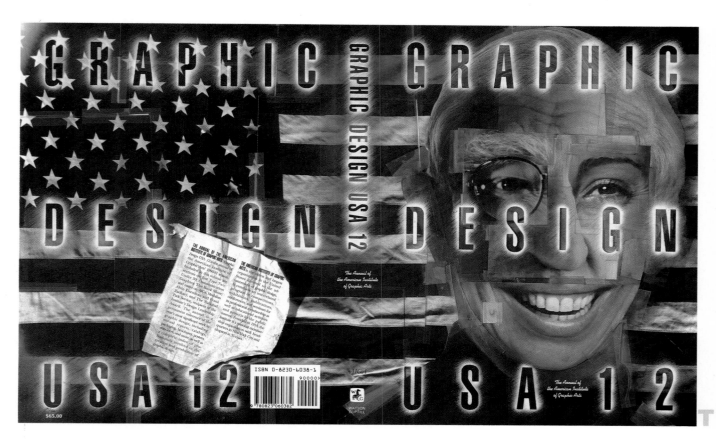

Cover of annual.

DESIGN FIRM: Muller+Co.,

Kansas City, Missouri

ART DIRECTOR/

DESIGNER: John Muller

PHOTOGRAPHER:

Michael Regnier

Poster ad.

AGENCY:

Wieden & Kennedy,

Philadelphia, Pennsylvania

ART DIRECTOR/

DESIGNER/ILLUSTRATOR:

Vince Engel

COPYWRITER: Jerry Cronin

ILLUSTRATOR:

Charles S. Anderson

The Subaru SVX

NORTHERN LIGHTS

*Stopped for an hour and watched the Northern Lights.
It was even better than Rocky III.*

On August 28th, Ken Knight test drove a new SVX. 9 days and 5,257 miles later he brought it back.

CALL HIM CRAZY. CALL HIM KEN KNIGHT. HE ANSWERS TO BOTH. Ken and his esteemed partner, Bob Dart, decided to enter one of the toughest and most grueling races in the world. The Alcan 5,000 Rally. And they decided to do it in a brand new, borrowed Subaru SVX.™

Ken and Bob didn't modify the car one little bit. No special suspension. No special transmission. No additional safety features. Even though for the nine days they would be driving over mountains, dodging bears, and speeding around the greatest collection of curves ever assembled.

People had warned them to be prepared for the worst and to make sure they carried lots of spare parts. Bob and Ken listened to all they had to say and reluctantly agreed to bring along an extra fuel filter and another set of windshield wipers.

*We'll take the high road.
You take the low road.*

As Ken put it: "It's a Subaru. How much can go wrong?" (Still, if anything did go wrong, they'd be stranded out in the wilds and out of the race.)

The race began in Seattle and continued through Canada and Alaska. All Ken and Bob had to do was maintain an average speed of 51 miles per hour. Which is easy when you're on a paved interstate. But pretty darn difficult when you're crossing 10,000-foot mountain passes and driving over dirt roads with another curve every thirteen feet or so,

Still, thanks to the 230 horsepower engine in the SVX, they stayed right on schedule. (Ken still refuses to say how fast they were traveling. And prefers to simply classify their overall driving style as "aggressive.")

Aggressively, they traveled over the Northern Rockies. Down the Cascade Mountain Range. And through rainy mosquito-infested forests, and the bustling, booming metropolis of Chicken, Alaska.

GR-R-R

Another roadside attraction: 8-foot Grizzlies.

Finally, after another 30 hours of driving, Ken and the 6-foot 7-inch Bob pulled into Jasper, Alberta, having accumulated only 15 penalty points, which was good enough for an all-time record and a first-place finish.

To be perfectly honest, Ken and Bob did run into a little trouble along the way. A pothole just south of Destruction Bay. The crater damaged a tire, which wasn't nearly as terrible as what it did to the poor Saab behind them — it ate up their struts and suspension.

That was it for the entire trip. One slightly blemished wheel. Proving, once again, that while anyone can make a car for the human race, it's Subaru who can make a car for an inhuman one.

The Subaru SVX.

Subaru. What to drive.™

© 1991 Subaru of America

T

Poster protesting the Gulf War and President Bush's inattention to domestic issues.

DESIGNER:

Patrick JB Flynn/The Progessive Magazine, Madison, Wisconsin

ART DIRECTOR:

Wes Anderson/Village Voice

ILLUSTRATOR:

Stephen Kroninger

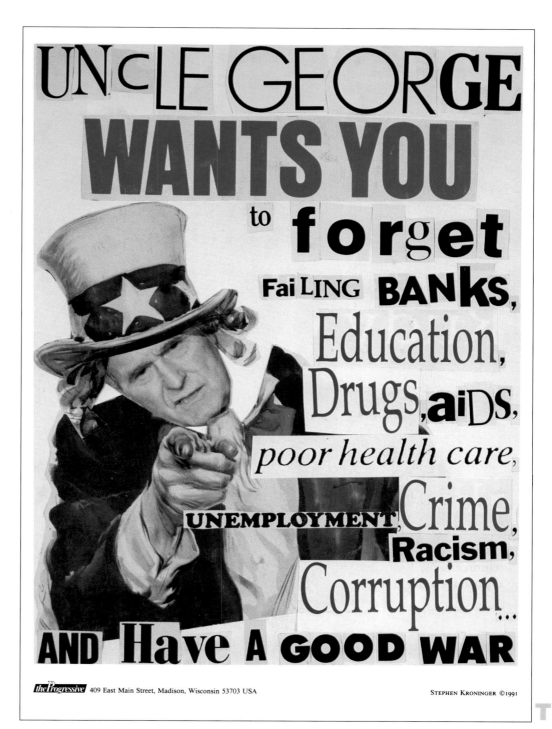

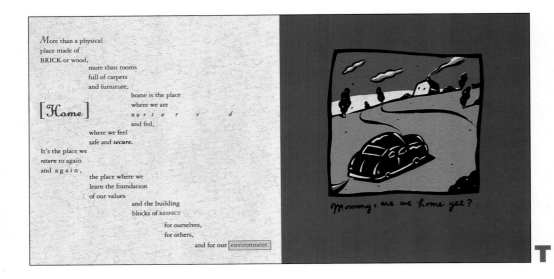

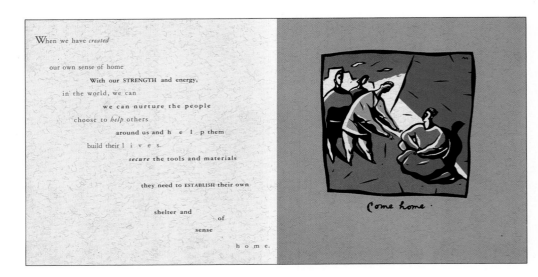

Front and back covers and inside spreads from self-promotional holiday greeting booklet.

DESIGN FIRM:

Stewart Monderer Design, Inc., Boston, Massachusetts

ART DIRECTORS:

Robert S. Davison, Stewart Monderer

DESIGNERS:

Robert S. Davison, Jane Winsor

ILLUSTRATOR:

Mark Matcho

Cover and inside spreads
from public relations and
fundraising brochure.
ART DIRECTOR/
DESIGNER: Celia Metcalf/
MIT Design Services,
Cambridge, Massachusetts
COPYWRITER:
Elizabeth T. Harding

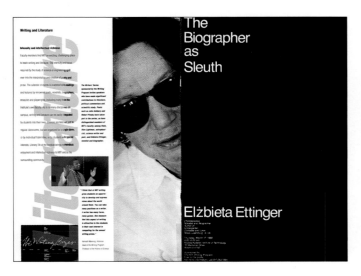

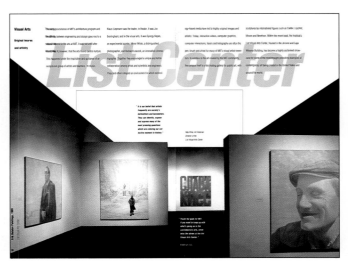

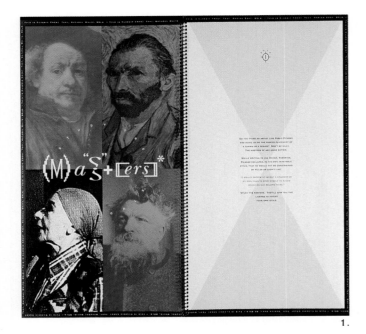

1.

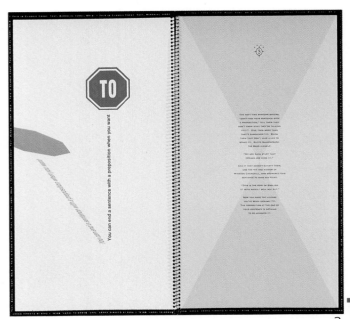

2.

3.

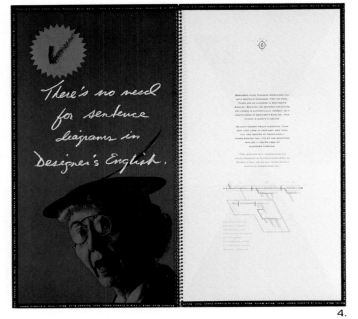

4.

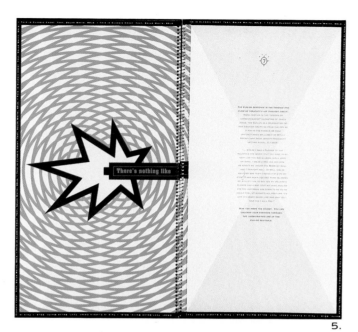

5.

Cover (3), inside spreads
(1,2,4) and fold-out inside
spread (5,6) from "The
Designer's English Primer"
paper promotion.
DESIGN FIRM:
Copeland Design, Inc.,
Atlanta, Georgia

ART DIRECTOR:
Brad Copeland
DESIGNERS: Suzy Miller,
Kathi Roberts Brown,
Fumiko Ogyu, Kevin Irby,
Lisa Farmer

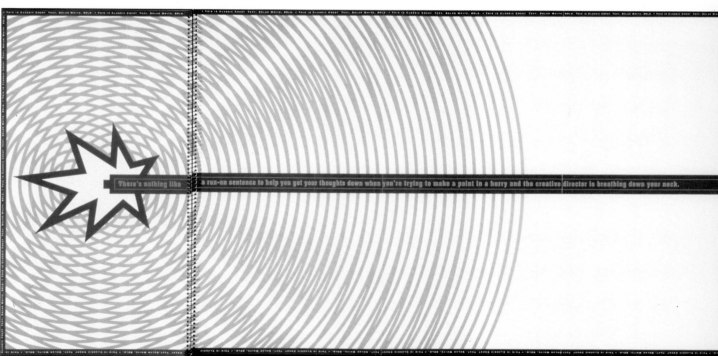

6.

Promotional poster for

exhibit of Carter's work at

Seybold Seminars '92.

DESIGN FIRM:

Koepke Design Group,

Gloucester, Massachusetts

ART DIRECTOR/

DESIGNER: Gary Koepke

PHOTOGRAPHER:

Steve Marsel

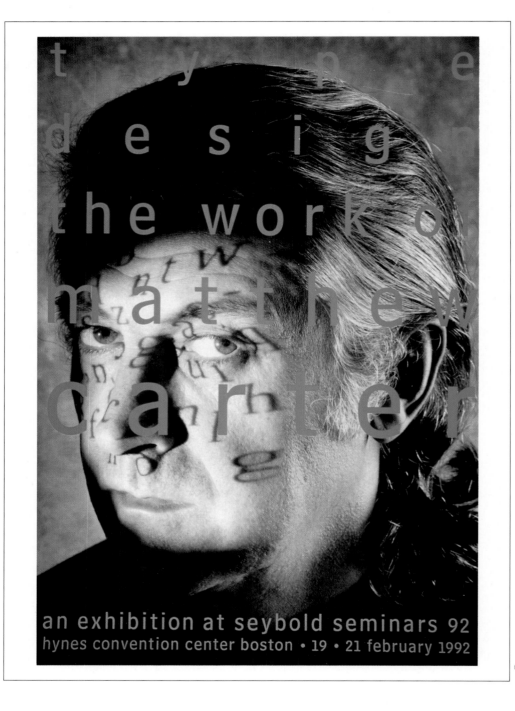

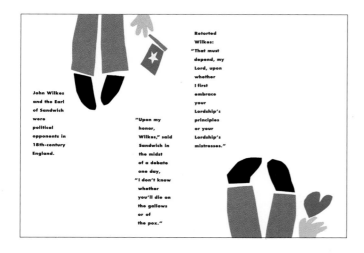

John Wilkes and the Earl of Sandwich were political opponents in 18th-century England.

"Upon my honor, Wilkes," said Sandwich in the midst of a debate one day, "I don't know whether you'll die on the gallows or of the pox."

Retorted Wilkes: "That must depend, my Lord, upon whether I first embrace your Lordship's principles or your Lordship's mistresses."

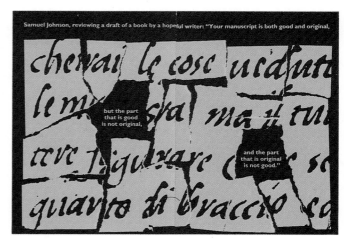

Samuel Johnson, reviewing a draft of a book by a hopeful writer: "Your manuscript is both good and original, but the part that is good is not original, and the part that is original is not good."

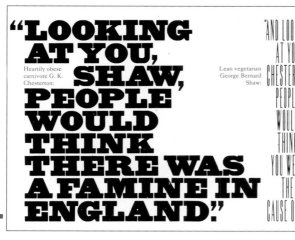

"LOOKING AT YOU, SHAW, PEOPLE WOULD THINK THERE WAS A FAMINE IN ENGLAND."

Heartily obese carnivore G. K. Chesterton:

"AND LOOKING AT YOU, CHESTERTON, PEOPLE WOULD THINK YOU WERE THE CAUSE OF IT."

Lean vegetarian George Bernard Shaw:

AT THE END of a long evening, Winston Churchill stumbled into a member of the House of Commons from Liverpool named Bessie Braddock. "Why, Sir Winston," she sniffed, "you're disgustingly drunk." "And I might say, Mrs. Braddock," answered Churchill pleasantly, "you are disgustingly ugly. However, tomorrow, I shall be s o b e r ."

Spreads from "A Child's Treasury of Smart-Ass Remarks" promotional booklet.

DESIGN FIRM:

Pentagram Design, New York, New York

PARTNER/DESIGNER/ COPYWRITER:

Michael Bierut

DESIGNERS: Dorit Lev, Anne Cowin

PHOTOGRAPHER:

Reven TC Wurman

Poster (2) promoting the club's fifth annual exhibition of the best in medical advertising. Fold-out, self-mailing call-for-entries (1).

DESIGN FIRM:

KSP Communications, Woodbridge, New Jersey

ART DIRECTOR/

DESIGNER: Jeffrey Pienkos

COPYWRITER:

Daniel Sturtevant

PHOTOGRAPHER:

William Wagner

1.

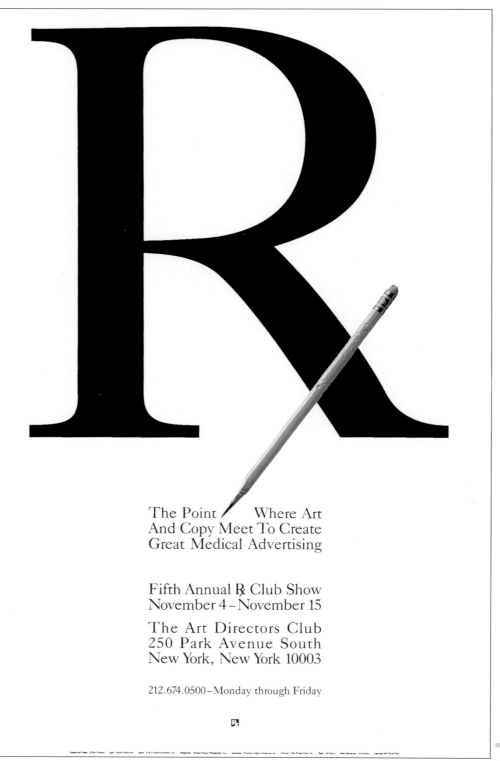

The Point / Where Art And Copy Meet To Create Great Medical Advertising

Fifth Annual Rx Club Show
November 4 – November 15

The Art Directors Club
250 Park Avenue South
New York, New York 10003

212.674.0500 – Monday through Friday

2.

140

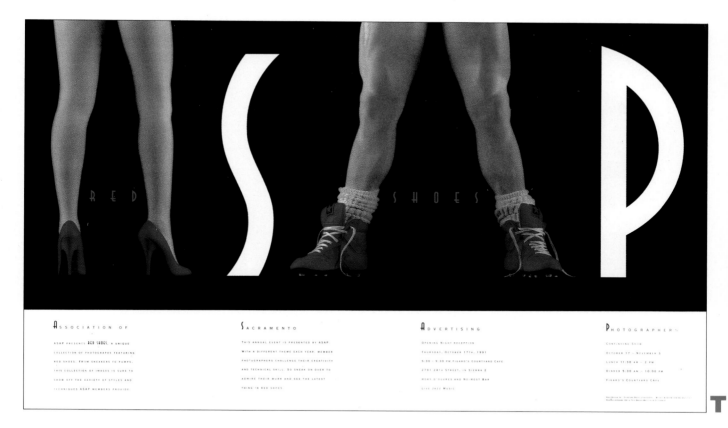

Poster promoting annual

photography show, whose

theme for 1991 was

"Red Shoes."

DESIGN FIRM:

Page Design, Inc.,

Sacramento, California

ART DIRECTOR: Paul Page

DESIGNER: Brad Maur

PHOTOGRAPHER:

Donald Satterlee

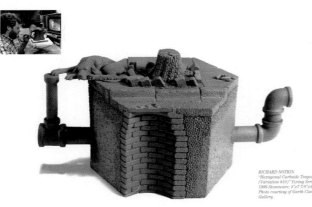

ALUMNI OF KANSAS CITY ART INSTITUTE

RICHARD NOTKIN
"Hexagonal Curbside Teapot
(Variation #10)" Yixing Series
1986-Stoneware, 4"x7 7/8"x4 1/8",
Photo courtesy of Garth Clark
Gallery.

RICHARD NOTKIN

Nineteen-ninety was a busy year for Richard Notkin. The KCAI graduate (B.F.A.-Ceramics, 1970) received a John Simon Guggenheim Memorial Foundation Fellowship, taught as a visiting artist in Jerusalem, and a solo show of his work was presented at several museums and galleries including the Seattle Art Museum, Honolulu Academy of Art, UMKC Gallery of Art in Kansas City, and the Schneider Museum of Art in Ashland, Oregon.

His work is in numerous private and public collections, including the Carnegie Museum of Art in Pittsburgh, Cooper-Hewitt Museum in New York, the National Museum of American Art (Smithsonian Institution), Los Angeles County Museum of Art, London's Victoria and Albert Museum, and the Nelson-Atkins Museum of Art in Kansas City.

KCAI: How did you decide to pursue a career in ceramics?
Richard Notkin: When I first came to the Art Institute in 1966, ceramics was probably the very last medium I would've considered. I stumbled onto it as a sculpture student when I was a Junior. A friend of mine was working in clay and I was in a moment of frustration. I'd tried bronze casting, wood, fiberglass and other materials. I didn't know where to go next. I simply started playing with clay and I've been playing with it ever since.

KCAI: You've said that ceramics is a medium that can remain fascinating during a lifetime of exploration. As an artist, what is your role in maintaining that fascination?
RN: I can't really express in words what it is about clay that really began that fascination. At this point, my only regret is that I only have one life and I have about three lifetime's worth of ideas to explore. Physically, I'm still fascinated by the fact that clay is the ultimate chameleon material; it can imitate any other material. I'm fascinated with the degree of intricacy that it allows me to achieve in my work.

KCAI: Throughout your career, social concerns have been important to your work. Do you consider yourself an activist working in a creative arena?
RN: To the degree that a ceramic artist can be an activist. As an artist you spend a lot of time alone in your studio so you're not an activist in the traditional sense. You're not out on marches. You're not testifying before Congress. But you are constantly putting images in front of the public that reflect your views. I think there's a need for that within gallery and museum spaces as well as in legislative bodies. Change begins with individuals and I think art can reach more individuals than the traditional political avenues.

KCAI: What about the relationship between social commentary and making art?
RN: I always tell my students when they're interested in social commentary in their ceramic work that their first responsibility is to make good art. If they want to make a statement that will have any kind of effectiveness or impact, both in the present and in the future, it has to be good art. If they then want to include social commentary, it shouldn't impede the fact that it's good art. Nor will it make it good art.

KCAI: How do you define "good" art?
RN: That definition is very personal and is constantly changing, constantly evolving. When I look back on my work, there are very few pieces that I'm satisfied with today. They were the best that I could do at the time, and I think of them as such. Good art is something you're always striving to achieve rather than something you can say that you've done.

I'M STILL FASCINATED BY THE FACT THAT CLAY IS THE ULTIMATE CHAMELEON MATERIAL

RICHARD NOTKIN

AKIO TAKAMORI

After years of study in his native Japan, Akio Takamori received a B.F.A.-Ceramics from KCAI in 1976. During the past 15 years, his career has combined teaching, studio work and exhibitions. His work appears in public and private collections including the Victoria and Albert Museum in London, the Los Angeles County Museum, Carnegie Museum of Art in Pittsburgh and KCAI.

KCAI: The vessel is a classic form for ceramic artists. What does it represent to you and why does it play such an important role in your work?
Akio Takamori: Vessels are not two-dimensional paintings and they're not three-dimensional sculpture; they have their own place somewhere between. They're well-suited to my work, which is very pictorial. Vessels have an inside and an outside, a front and a back. That gives me more areas to paint. My work is very narrative and vessels let me include a lot of information.

KCAI: The images in your work frequently juxtapose opposites — male and female, love and hate, life and death. Do contrasting opposites inspire you?
AT: Opposites exist in the world and I'm interested more in accepting these opposites than trying to explain them. My work is my way of accepting them.

KCAI: Is it important for you to communicate a sense of mystery and suspense in your work?
AT: You mean shock value? Sometimes I do and sometimes I don't; it depends on the image I'm working with. When I was younger, I was working more that way; trying to create something suspenseful, something with shock value. But I don't think I do it as intentionally as I used to.

KCAI: What led to that change?
AT: Life is more settled, more comfortable. When you're raising a family, you become more conservative. I think it's a matter of becoming more conservative with age.

My work has changed by this stage of my life and because my images come from things very close to me — my family; how I think; what's happening around me. The imagery one is dealing with changes. I'm putting more 'thinking' into my work than when I was younger. I'm thinking more about family, getting older, the end of my life. Those images are coming into my work more and more.

KCAI: How are those images articulated in your most recent work?
AT: In my last group of work, I dealt with environmental images, protecting the environment, and what has happened in Eastern Europe, the changes in governments. The modern ideology we grew up with has fallen apart. These things have affected my work.

KCAI: There have also been changes in your personal life, especially with the birth of your two children. Are you incorporating images of children into your work?
AT: I've done a lot of birth images. When I do a portrait of children, it is a reflection of myself. When I'm thinking about my son's relationship with my mother and with my wife. It makes me think about my own childhood, my own life, and my own death.

IT MAKES ME THINK ABOUT MY OWN CHILDHOOD, MY OWN LIFE, AND MY OWN DEATH.

AKIO TAKAMORI

AKIO TAKAMORI
"Bust of a Woman"
1991-Porcelain,
27" high, Photo
courtesy of Garth
Clark Gallery.

8

T

Cover and spread from

alumni magazine,

Assemblage.

DESIGN FIRM: Muller+Co.,

Kansas City, Missouri

ART DIRECTOR/

DESIGNER: John Muller

DESIGNER: Scott Chapman

Cover and inside spreads
from a promotion booklet
for the Pushpin Illustrators.
DESIGN FIRM:
The Pushpin Group, Inc.,
New York, New York
ART DIRECTOR:
Seymour Chwast
DESIGNER: Greg Simpson

Color can transform your buffet into a Valentine's Day showcase.

Red and White DELight!

Valentine's Day is the time to show people how much you care about them. And when you're listing those who care about you, don't forget to include yourself.

Take a few minutes to remember your accomplishments this Valentine's Day. Think of others who care about you, too, whether they always find the words to tell you so or not. And keep in mind that the best valentine you can give yourself—and those who care about you—is your good health.

If possible, surround yourself with cherished friends

by Sue Thom, Karmeen Kulkarni, Mary Austin

28 **Diabetes Forecast** February 1992

Spread from Diabetes
Forecast magazine.

DESIGN FIRM:

Tom Suzuki, Inc., Falls

Church, Virginia

ART DIRECTOR: Tom Suzuki

DESIGNER: Timothy Cook

ILLUSTRATOR: Lilla Rogers

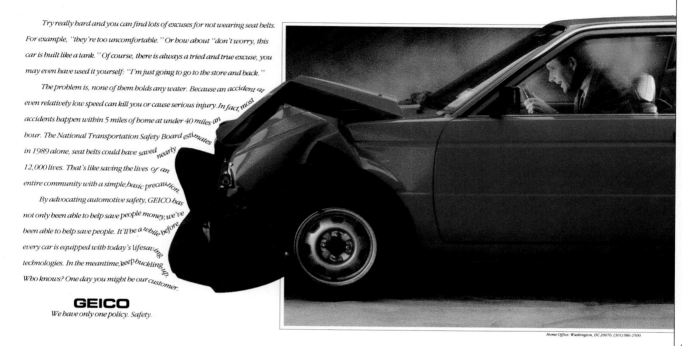

If you think seat belts will wrinkle your outfit, imagine what your dashboard will do to it.

Try really hard and you can find lots of excuses for not wearing seat belts. For example, "they're too uncomfortable." Or how about "don't worry, this car is built like a tank." Of course, there is always a tried and true excuse, you may even have used it yourself: "I'm just going to go to the store and back."

The problem is, none of them holds any water. Because an accident at even relatively low speed can kill you or cause serious injury. In fact, most accidents happen within 5 miles of home at under 40 miles an hour. The National Transportation Safety Board estimates in 1989 alone, seat belts could have saved nearly 12,000 lives. That's like saving the lives of an entire community with a simple, basic precaution.

By advocating automotive safety, GEICO has not only been able to help save people money, we've been able to help save people. It'll be a while before every car is equipped with today's lifesaving technologies. In the meantime, keep buckling up. Who knows? One day you might be our customer.

GEICO
We have only one policy. Safety.

Home Office: Washington, DC 20076. (301) 986-2500.

Magazine ad.

AGENCY:

Earle Palmer Brown,

Bethesda, Maryland

ART DIRECTOR:

Barbara Scardino

COPYWRITER: Daniel Russ

PHOTOGRAPHER:

Jim Erickson

Promotion for Champion

Groove paper.

DESIGN FIRM:

Larson Design Associates,

Rockford, Illinois

ART DIRECTOR: Jeff Larson

DESIGNER: Scott Dvorak

COPYWRITER:

Keith Christianson

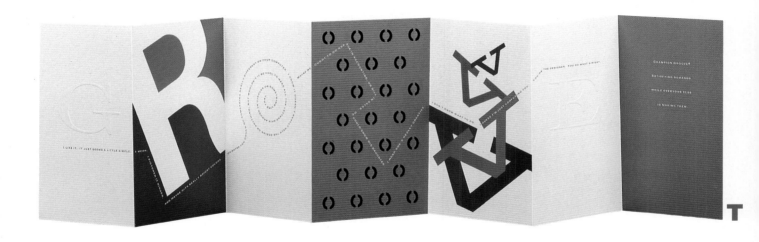

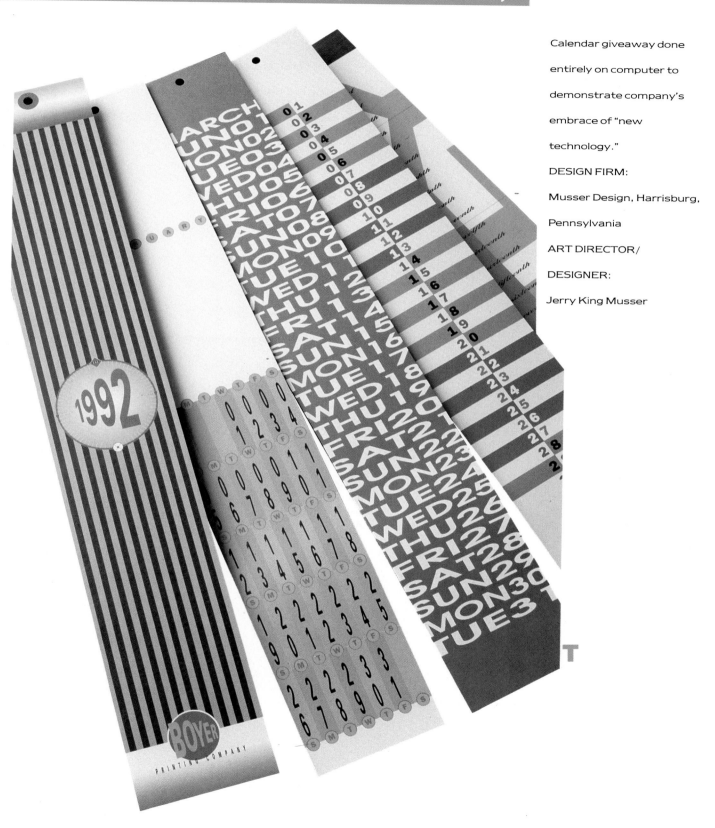

Calendar giveaway done entirely on computer to demonstrate company's embrace of "new technology."

DESIGN FIRM:

Musser Design, Harrisburg, Pennsylvania

ART DIRECTOR/

DESIGNER:

Jerry King Musser

Cover and spread from capabilities brochure for a cable television data processing and mailing service.

DESIGN FIRM:

Bozell Advertising/Omaha, Omaha, Nebraska

ART DIRECTOR: Bill Ervin

DESIGNERS: Bill Ervin, Chris Buhrman

ILLUSTRATOR: Chris Buhrman

Our operating systems are continually updated and refined, and our production services manager has actively served as chairman of the Postal Customer Council and is involved with rapidly changing postal regulations as well as trends in the industry. Since mailing and related operations are our specialties, you eliminate costly start-up and processing time at your end. With our operation constantly up and running, your need for similar systems is eliminated. In short, we know mailing so you won't have to.

Spreads from "Everything Old Is New Again" promotional booklet.
DESIGN FIRM:
Little & Company,
Minneapolis, Minnesota
CREATIVE DIRECTOR:
Paul Wharton
DESIGNERS: Paul Wharton,
Ted Riley

Jazz is back. Again. Before World War I they called it "Ragtime," the syncopated folk music of New Orleans Creoles. The audience was originally working people of the Delta. But not for long. By 1920 Jazzy Music (and its first great genius, Louis Armstrong) had millions of Americans snapping their fingers. It was the new wave. Even band leaders like Paul Whiteman added a touch of Jazz to their sound. 1930 brought the Depression and fine jazz players throughout America and Europe. About then, George Gershwin was writing Symphonic Jazz pieces like "Rhapsody in Blue". By 1940 Jazz was Swing in the hands of people like Tommy Dorsey and Glenn Miller. The cool 1950s brought the cerebral *Progressive Jazz* of Dave Brubeck, The Jazz Messengers, and Theolonius Monk. The 1960s gave birth to *Rhythm and Blues*. But it's all Jazz. You can't stop it. You might as well sit back and snap your fingers. But please, after the beat.

Book cover.

DESIGN FIRM:

Robert Overby, Glendale,

California

DESIGNER/ILLUSTRATOR:

Robert Overby

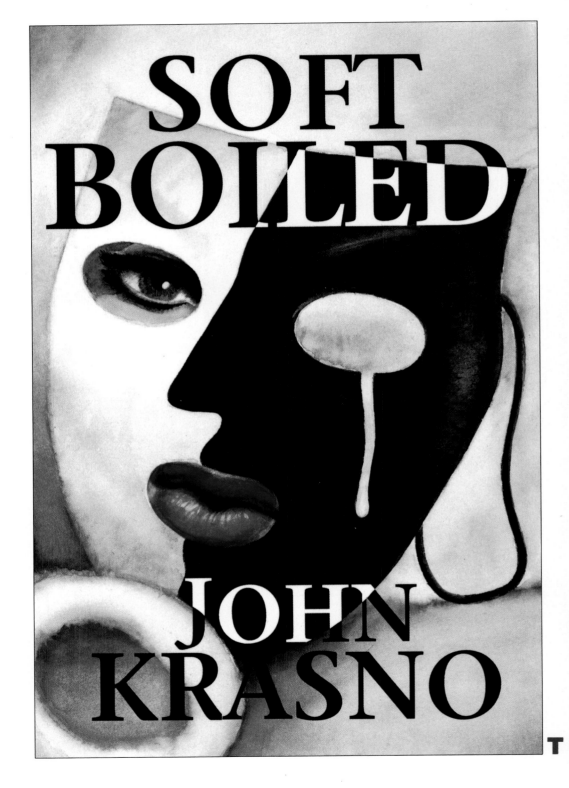

Poster for volunteer program teaching illiterate adults to read.

ART DIRECTOR/
DESIGNER:

Joe Paprocki/The Ralphus Group, Atlanta, Georgia

AGENCY:

Earle Palmer Brown

COPYWRITER: Rich Paschall

There's...nuh...thing quite...as...re...ward ing...as...hear....ing an...ad...dult...read for.....the........vair ree......first....time.

Teach an adult illiterate how to read. You don't need any special skills or experience. All you need is the desire to make a difference in someone's life. Call us at 491-8160 to find out how you can become a volunteer teacher. Only then will you discover the true joys of reading. PROJECT READ

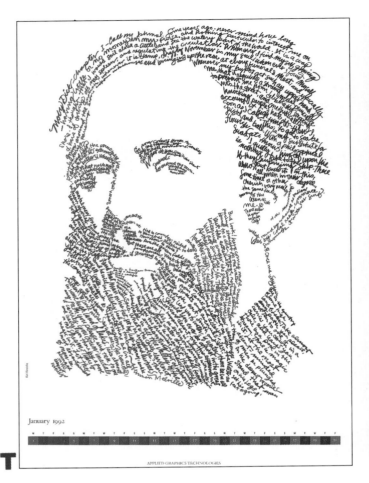

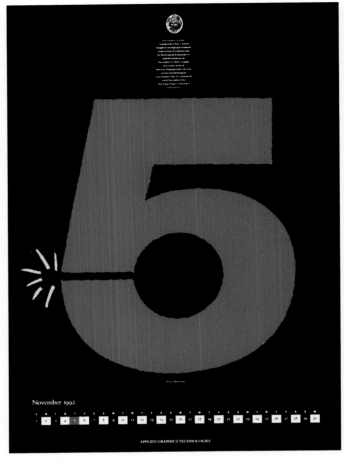

Cover and pages from 1992
promotional calendar
whose theme is "celebrity
birthdays."

DESIGN FIRM:

Pentagram Design,

New York, New York

ART DIRECTOR/

DESIGNER: Harold Burch

ARTISTS: Michael Gericke,

Harold Burch (Cover), Kit

Hinrichs (January), Peter

Harrison (November)

PHOTOGRAPHERS:

Bill Whitehurst (Cover)

TYPOGRAPHY:

Type Systems/Applied

Graphics Technologies

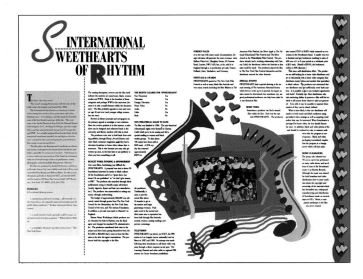

Cover and inside spreads from publication presenting case studies of three video documentaries.

DESIGN FIRM:

LaGuardia Communications, Long Island City, New York

ART DIRECTOR/ DESIGNER/ILLUSTRATOR:

Bill Freeland

COPYWRITER:

Michael Wiese

CD packaging.

ART DIRECTOR:

Tommy Steele/Capitol Art

Department, Hollywood,

California

DESIGNER: Stephen Walker

PHOTOGRAPHER:

Annie Leibovitz

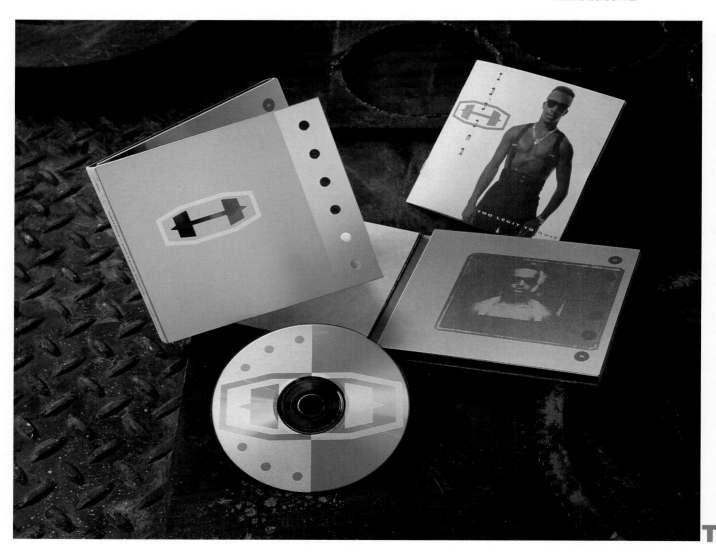

Holiday self-promotion.

DESIGN FIRM:

Courage Design, Buffalo,

New York

DESIGNERS: Alan Kegler,

Carol Wannemacher

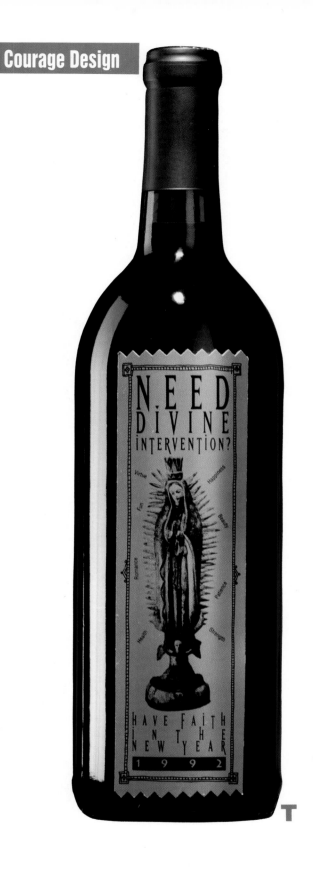

Book cover.

DESIGN FIRM:

Syndi Becker Design,

New York, New York

ART DIRECTOR:

Doris Janowitz/Farrar

Straus & Giroux

DESIGNER: Syndi Becker

AIRBRUSH ARTIST:

Ralph Wernli

WHiCH SiDe ARe YOU ON?

TRYING TO BE FOR LABOR

WHEN IT'S FLAT ON ITS BACK

―――――

THOMAS GEOGHEGAN

T

Book cover.

ILLUSTRATOR:

Cathleen Toelke,

Rhinebeck, New York

ART DIRECTOR: Frank Metz

DESIGNER: Jackie Seow

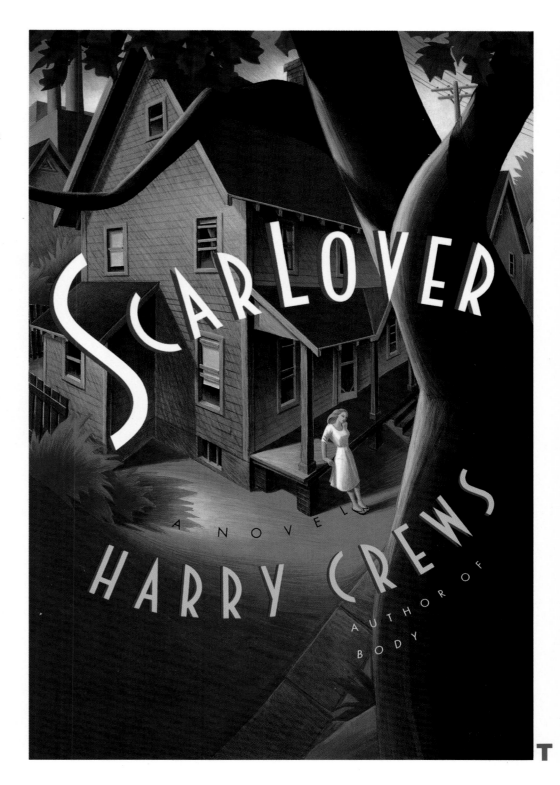

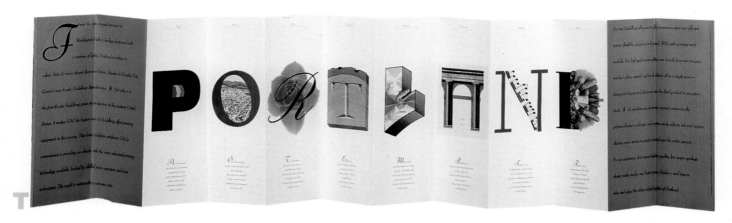

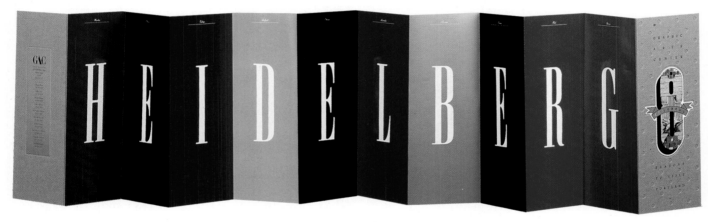

"Eight Colorful Reasons to Visit Portland" fold-out announcement of new eight-color press.

DESIGN FIRM:

Pentagram Design, San Francisco, California

ART DIRECTOR:

Kit Hinrichs

DESIGNER: Belle How

COPYWRITER:

Delphine Hirasuna

PHOTOGRAPHER:

Bob Esparza

Promotional catalog.

DESIGN FIRM:

Breiter Concepts Design &

Advertising, Monrovia,

California

ART DIRECTORS/

DESIGNERS: Carrie Breiter,

Allen Breiter

PHOTOGRAPHER:

Donald Graham

Cover and inside spread from announcement of lecture by designer Joel Katz.

DESIGN FIRM:
Peter Hollingsworth & Associates, Winston-Salem, North Carolina

DESIGNER:
Peter Hollingsworth

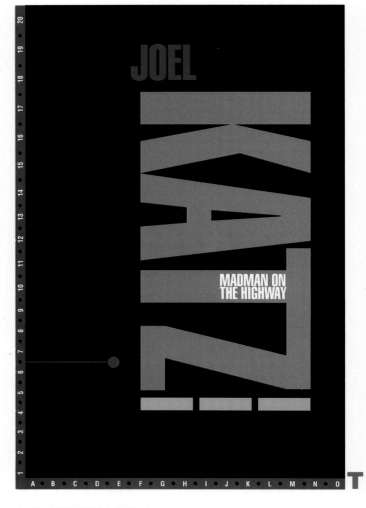

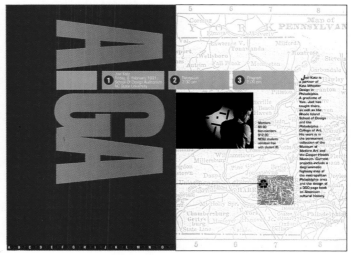

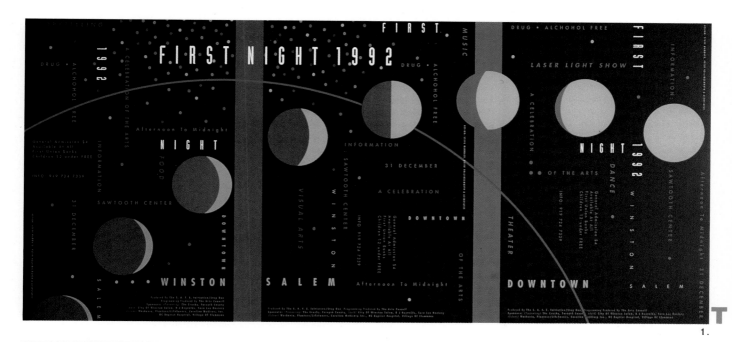

1.

2.

3.

Poster (1), program cover (2), program page (3), and button (4) promoting annual benefit festival.

DESIGN FIRM:

Peter Hollingsworth & Associates, Winston Salem, North Carolina

DESIGNER:

Steven John Wammack

S.A.F.E. DIRECTOR:

Mary Reese

4.

Promotional poster.

ART DIRECTOR/

DESIGNER/COPYWRITER:

Greg Cerny, Long Island

City, New York

AGENCY:

J. Walter Thompson

TYPOGRAPHER:

Steve Krauss

**CONSIDERING
THE PRICKS
YOU DEAL WITH
IN ADVERTISING,
GIVING BLOOD
SHOULD BE
NO PROBLEM.**

THE J. WALTER THOMPSON BLOOD DRIVE
January 23-24 · 2nd Floor Theatre · 8:30am-4:45pm

Poster promoting the
fall concert series of the
Philharmonia Orchestra of
Yale.
DESIGN FIRM:
Peter Nuhn/Graphic Design,
Stony Creek, Connecticut
DESIGNER: Peter Nuhn

Philharmonia Orchestra of Yale

Friday, October 4
Günther Herbig, conductor
Claude Cobert, flute
Mozart *Symphony No. 41 in C Major,*
 K. 551, "Jupiter"
Reinecke *Flute Concerto in D Major, Op. 283*
Dvorak *Symphony No. 9 in e minor,*
 Op. 95, "From the New World"

Friday, December 13
Eleazar de Carvalho, conductor
Debra Byrd, soprano
Britten *Les Illuminations, Op. 18*
Sellars *Machine Music*
Ravel *Rapsodie Espagñole*

All concerts 8:00 pm Woolsey Hall
Admission is free
Information 432-4158

Folder containing winners
of Gilbert Paper's student
letterhead-design
competition.
DESIGN FIRM:
Janet Odgis & Co. Inc.,
New York, New York
ART DIRECTOR: Janet Odgis
DESIGNERS: Janet Odgis,
Elizabeth Bakacs
STUDENT WINNERS:
Todd Hanswirth (1), Dan
Richards (2), David Warner
(3), Jeff Peterson (4).

1.

2.

3.

4.

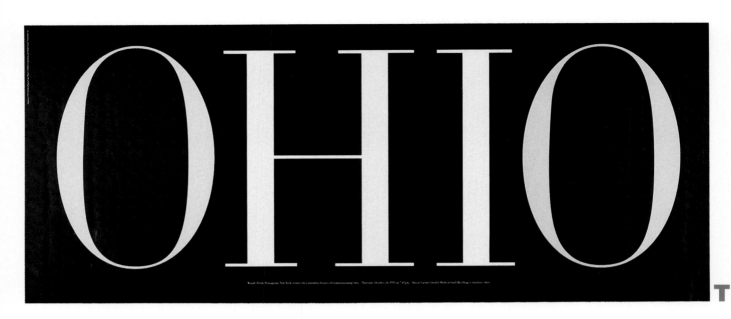

Poster announcing a talk
and presentation by Woody
Pirtle.
DESIGN FIRM:
Pentagram Design,
New York, New York

PARTNER/ART DIRECTOR/
DESIGNER/COPYWRITER:
Woody Pirtle
PARTNER/DESIGNER:
Paula Scher

Poster announcing a talk
and presentation by Paula
Scher in two Oklahoma
cities.

DESIGN FIRM:

Pentagram Design,

New York, New York

PARTNER/DESIGNER/

TYPOGRAPHER:

Paula Scher

DESIGNER: Ron Louie

Packaging for a writing
program for children.
DESIGN FIRM:
Woods+Woods,
San Francisco, California
ART DIRECTOR/
DESIGNER: Alison Woods
ILLUSTRATOR: Paul Woods

Coffee packaging.

DESIGN FIRM:

The Dunlavey Studio,

Sacramento, California

ART DIRECTOR:

Michael Dunlavey

DESIGNERS:

Heidi Tomlinson, Lindy

Dunlavey

Cover and spreads from
1991 annual report.

DESIGN FIRM:
Morava Oliver Berté, Santa
Monica, California

ART DIRECTOR/
DESIGNER: Jim Berté
COPYWRITER: John Tuffy
PHOTOGRAPHER:
Russ Widstrand

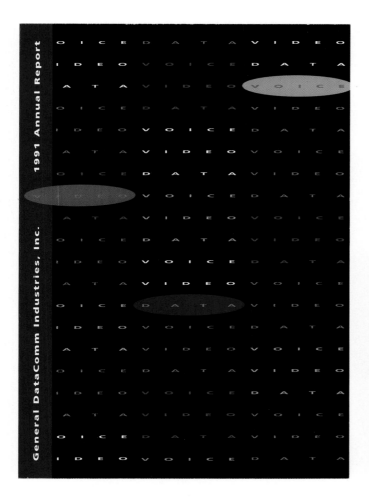

Cover and spreads from 1991 annual report for a company that provides multimedia networks and telecommunications equipment worldwide.

DESIGN FIRM:

Ted Bertz Design, Inc.,

Middletown, Connecticut

ART DIRECTOR/ DESIGNER:

Ann Marie Ternullo

COPYWRITER:

Theresa A. Carpentieri

ILLUSTRATOR:

Andrea Wisnewski

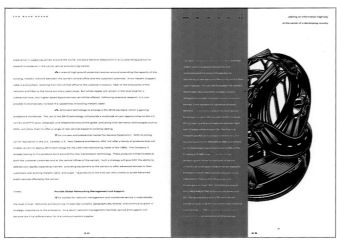

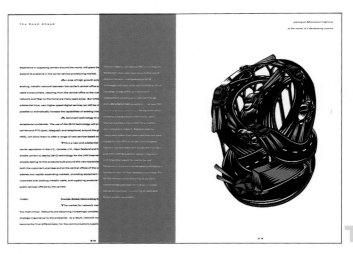

Cover and spreads from the
Institute's brochure
promoting participation in
the arts progam at LaCoste
School of the Arts in France.
DESIGN FIRM:
Nesnadny & Schwartz,
Cleveland, Ohio
ART DIRECTOR/
DESIGNER: Joyce Nesnadny

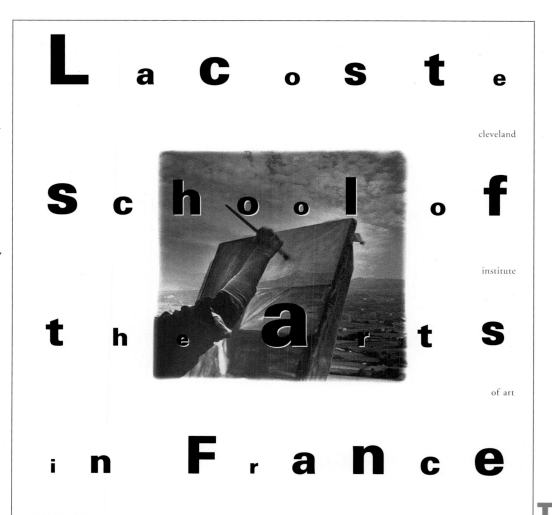

cleveland

institute

of art

L a C o s t e
S c h o o l o f
t h e a r t s
i n F r a n c e

T

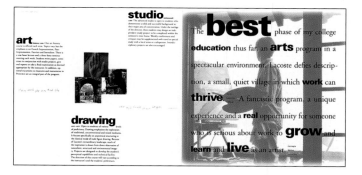

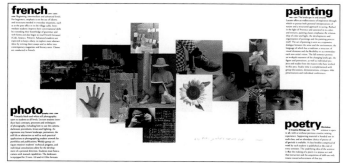

172

Ronzoni pasta ad.

AGENCY:

Pedone & Partners,

New York, New York

ART DIRECTOR:

Victor Mazzeo

COPYWRITER:

Leticia Martin

PHOTOGRAPHER:

Chris Collins

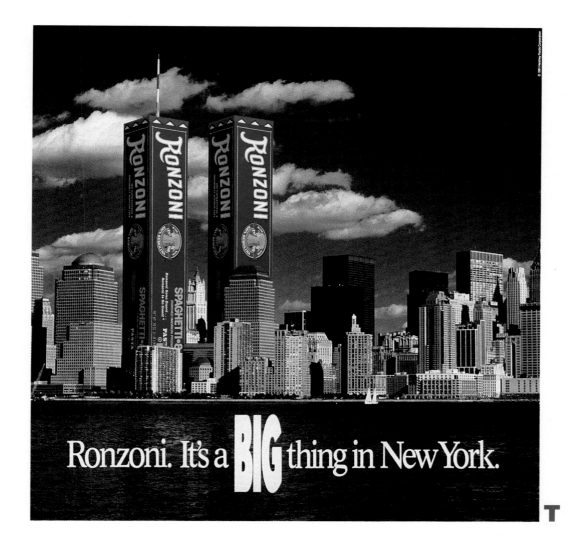

Ronzoni. It's a **BIG** thing in New York.

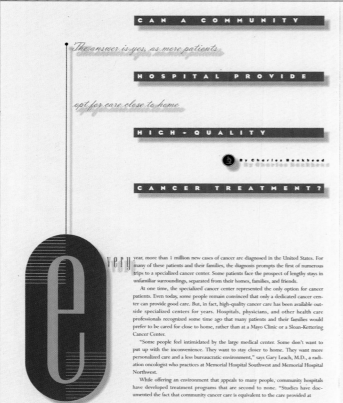

CAN A COMMUNITY

The answer is yes, as more patients

HOSPITAL PROVIDE

opt for care close to home

HIGH-QUALITY

By Charles Bankhead

CANCER TREATMENT?

every year, more than 1 million new cases of cancer are diagnosed in the United States. For many of these patients and their families, the diagnosis prompts the first of numerous trips to a specialized cancer center. Some patients face the prospect of lengthy stays in unfamiliar surroundings, separated from their homes, families, and friends.

At one time, the specialized cancer center represented the only option for cancer patients. Even today, some people remain convinced that only a dedicated cancer center can provide good care. But, in fact, high-quality cancer care has been available outside specialized centers for years. Hospitals, physicians, and other health care professionals recognized some time ago that many patients and their families would prefer to be cared for close to home, rather than at a Mayo Clinic or a Sloan-Kettering Cancer Center.

"Some people feel intimidated by the large medical center. Some don't want to put up with the inconvenience. They want to stay closer to home. They want more personalized care and a less bureaucratic environment," says Gary Leach, M.D., a radiation oncologist who practices at Memorial Hospital Southwest and Memorial Hospital Northwest.

While offering an environment that appeals to many people, community hospitals have developed treatment programs that are second to none. "Studies have documented the fact that community cancer care is equivalent to the care provided at

22 CARING/WINTER 1992

MEMORIAL HEALTHCARE SYSTEM 23

Spread from Caring magazine.
DESIGN FIRM:
Geer Design, Inc.,
Houston, Texas
ART DIRECTOR/
DESIGNER: Mark Geer
ILLUSTRATOR:
James Endicott

FROM SHAKESPEARE TO SQUARE DANCING, world affairs to regional art, you'll discover journeying on Royal Viking Line's *Americana* and other cruises offers attractions that are part of the special character, heritage, and experience of Royal Viking Line.

For beyond grand ships and great destinations, we know Royal Viking Line passengers delight in a full spectrum of stimulating activities, new experiences, and entertaining events. We're constantly working to develop special enhancements to surprise and delight even those Skalds who have sailed with us dozens of times.

THAT BIG BAND SOUND

A perennial favorite is that unmistakable sound of big band. Our upcoming fall (and past springtime) cruises feature a veritable Big Band Hall of Fame. How about the Tommy Dorsey Orchestra, Guy Lombardo's Royal Canadians with Al Pierson, the Harry James Orchestra, Les Elgart and his Orchestra, and the Glenn Miller Orchestra to top it off? And to help passengers enjoy this tidal wave of great sound, we provide classic ballroom dance lessons. Our instructors will make you so sure-footed, you'll still be out on the floor when the band starts playing "Three O'clock in the Morning." In addition, Royal Viking Line's hosts are on hand every evening to accompany ladies traveling alone.

If you really want to take a turn, perhaps square dancing's a step in the right direction. In an authentic celebration of a great American folk tradition, passengers will do-si-do on the Alaska cruises aboard the *Sky* this summer and early fall. Max and Kay Forsyth, professional callers who travel throughout the United States and Canada, will join us on a selection of cruises to instruct passengers in the stylistic maneuvers of the "allemande left" and the "birdie in a cage" – just so you swing your partner *on* board, not overboard.

FRONTIER FROLIC

And while we're highlighting Alaska cruises, you may want to know about our better-than-ever Gold Rush Klondike song and dance show, featuring the sights and sounds of gold fever which gripped the Yukon territory in the late 1890s. Everyone becomes a part of the full fifty minutes of colorful musical action, set in the Alaskan frontier. The evening lends the pioneer spirit to the entire cruise by showcasing the ragtime music and western songs and dances of the Alaskan gold rush.

In addition, the Ketchikan Ladies series continues to instruct passengers in ways "to see Alaska like natives." A representative from the Ketchikan Ladies joins each Alaskan cruise to discuss the history, geography, and local color of Royal Viking Line's Alaskan ports of call. Passengers might learn that Ketchikan natives never carry umbrellas despite the city's nearly 162" of rainfall or that Anchorage is one of the best ports for homegrown treats such as reindeer sausage and fireweed honey.

ORDER OF THE DAY

Our destination-specific entertainment itineraries capture the essence of each and every sailing. For example, the *RV Sun's Americana* cruise (May 11) visited one of the most notable regional events in America, Charleston, South Carolina's annual Spoleto Music Festival – complementary fête to the Spoleto Festival in Spoleto, Italy. Both celebrations feature the art, music, dance, and literature of young, international talent.

We continued our festivities of great music by joining the 80th birthday celebration for distinguished composer Gian Carlo Menotti as part of an optional tour in Charleston.

DID YOU KNOW

ROYAL VIKING'S FULL LINE OF ENTERTAINING EVENTS

Actress Elizabeth Taylor sailed to China on the *Royal Viking Star*.

Composer Marvin Hamlisch said he'd travel miles with RVL just for a bowl of our chilled peach soup.

Bob Hope celebrated a Christmas special on board the *RV Sun*?

Royal Viking Singers & Dancers make thirty costume changes per cruise.

12 13

1.

2.

3.

Cover (3) and spreads (1,2) from Skald, magazine for club members.

DESIGN FIRM:

Pentagram Design, San Francisco, California

ART DIRECTOR:

Kit Hinrichs

DESIGNER: Jackie Foshaug

COPYWRITERS:

Peterson, Skolnick & Dodge

ILLUSTRATOR:

Tim Lewis (1)

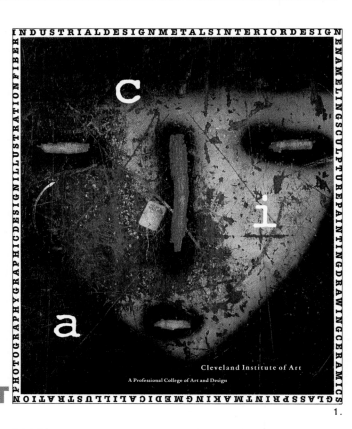

1.

Cover (1) and inside spread (2) from school catalog. Promotional poster (3).

DESIGN FIRM:

Nesnadny & Schwartz, Cleveland, Ohio

ART DIRECTORS/ DESIGNERS:

Joyce Nesnadny, Ruth D'Emilia

2.

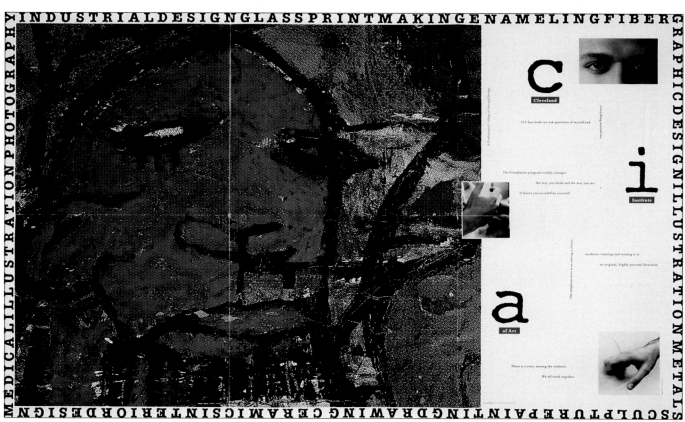

3.

Spreads from brochure promoting new programs and services.

DESIGN FIRM:

Art Center Design Office, Pasadena, California

ART DIRECTOR:

Rebeca Mendez

DESIGNERS:

Rebeca Mendez, Darren Namaye

PHOTOGRAPHER:

Steven A. Heller

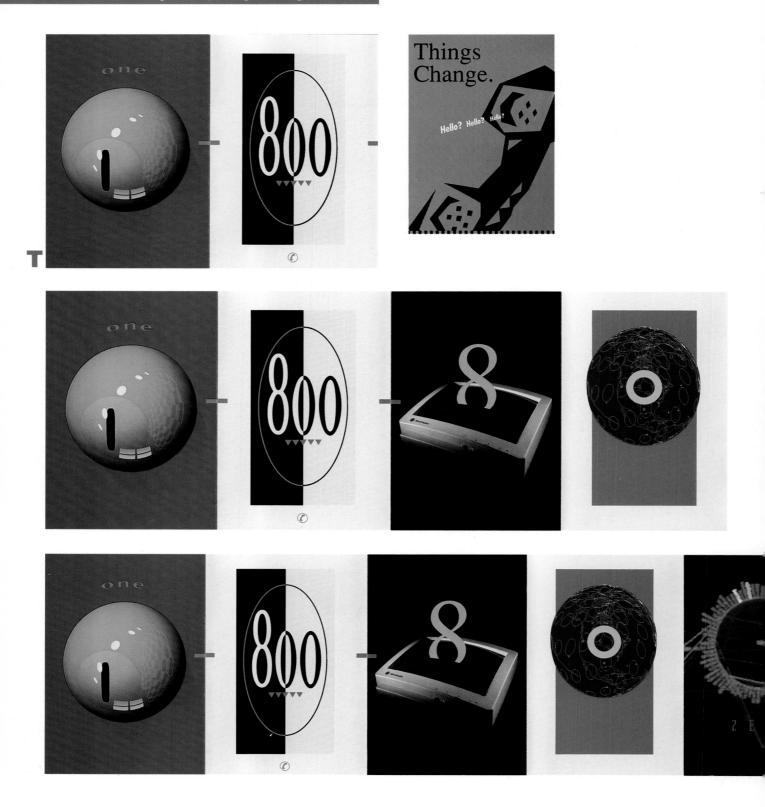

Self-mailing direct-mail piece announcing a new 800 number.
DESIGN FIRM:
Michael Patrick Partners, Palo Alto, California
ART DIRECTOR:
Dan O'Brien
DESIGNER/ILLUSTRATOR:
Scott Brown

Spreads and cover detail from 1992 calendar commemorating company's 200th anniversary.

DESIGN FIRM:
Bernhardt Fudyma Design Group, New York, New York

ART DIRECTORS:
Craig Bernhardt, Janice Fudyma

DESIGNER: Iris Brown

COVER TYPOGRAPHY:
Gerard Huerta

INTERIOR TYPOGRAPHY:
Bernhardt Fudyma Design Group

Promotional lunch bags.

ART DIRECTOR:

Pam Denman/Admark, Inc.,

Topeka, Kansas

DESIGNERS: Pam Denman,

Cara Lankard, Mike Snell

PHOTOGRAPHER:

Jon Hardesty

ILLUSTRATORS:

Pam Denman, Mike Snell

COPYWRITER:

Nancy Ramberg

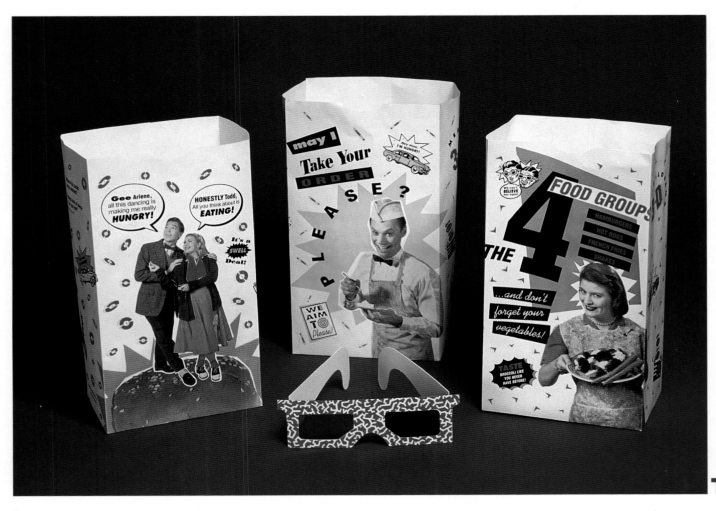

Cover and spreads from
1991 annual report.
DESIGN FIRM: INC Design,
New York, New York
ART DIRECTOR/
DESIGNER: Meera Singh

TECHNOLOGY PROGRAMS

THE OVERALL OBJECTIVE OF DRAPER LABORATORY'S TECHNOLOGY PROGRAMS IS TO ESTABLISH A BASE OF KEY TECHNOLOGIES THAT SUPPORT DRAPER'S DESIGNATED MISSION AREAS: THE PRIMARY FOCUS IS ON GUIDANCE, NAVIGATION, AND CONTROL; PHOTONIC INSTRUMENTS; AND MICROMECHANICAL INERTIAL INSTRUMENTS. THE CONSTANT GOAL IS TO DEVELOP BETTER-GRADE AND MORE PRODUCIBLE INERTIAL INSTRUMENTS.

IMPORTANT EFFORTS ARE ONGOING IN ELECTRONICS WITH NEW DEVELOPMENT PROGRAMS IN FAULT-TOLERANCE AND ADVANCED SIGNAL PROCESSING. INTELLIGENT SYSTEMS, THE AREAS OF INFORMATION AND ALGORITHMS, INFORMATION PROCESSING, AND ARTIFICIAL INTELLIGENCE ... THE WHOLE CONCEPT OF AUTONOMY... ARE HIGH-PRIORITY DEVELOPMENT AREAS. DRAPER IS WORKING TOWARD DEVELOPING ONBOARD SYSTEMS TO PROVIDE THE TYPE OF ADVANCED FUNCTIONS NECESSARY FOR AUTONOMOUS VEHICLE SYSTEMS.

DRAPER HAS A HISTORY OF WORK AND SUCCESS IN THE DEVELOPMENT OF ADVANCED AUTOMATION SYSTEMS. THE PROCESS OF BUILDING MECHANICAL INERTIAL INSTRUMENTS HAS BEEN AUTOMATED. THE 16-PIGA (PENDULOUS INTEGRATING GYRO ACCELEROMETER) AUTOMATED ASSEMBLY SYSTEM AUTOMATES THE FINAL CLEANING, ASSEMBLY, AND BONDING OF THE 16-PIGA WHEEL AND FLOAT ASSEMBLIES. TWO ASSEMBLY SYSTEMS WERE DEVELOPED AND BUILT AT DRAPER AND DELIVERED TO INDUSTRIAL CONTRACTORS. THIS AUTOMATION EXPERTISE IS BEING COUPLED WITH NEW INSTRUMENT WORK TO CREATE THE MECHANISM FOR THE HIGHLY AUTOMATED MANUFACTURE OF BOTH INTERFEROMETRIC AND FIBER-OPTIC INSTRUMENTS AS WELL AS MICROMECHANICAL INSTRUMENTS. OUR KNOWLEDGE AND EXPERIENCE DERIVED FROM THE DEVELOPMENT OF NEW TECHNOLOGY AIMED AT AUTOMATING APPAREL MANUFACTURING IS BEING APPLIED TO OTHER AREAS OF AUTOMATION. THE TEXTILE CLOTHING TECHNOLOGY CORPORATION SPONSORED EFFORT HAS LED TO A TECHNOLOGY DEVELOPMENT PROGRAM INVOLVING AUTOMATING THE MANUFACTURE OF COMPOSITE STRUCTURES.

PAST PERFORMANCE AND ACCOMPLISHMENTS BLEND WELL WITH GROWING OPPORTUNITIES IN MAGNETIC BEARINGS, REACTION AND MOMENTUM WHEELS FOR SPACE VEHICLES, OCEANOGRAPHIC INSTRUMENTATION, AUTOMATED SOFTWARE DEVELOPMENT, AND SENSORS. ALL THESE INITIATIVES HAVE APPLICATIONS TO DRAPER LABORATORY'S DESIGNATED MISSION AREAS.

14.

"New technology has been and will continue to be the lifeblood of Draper Laboratory. Although technology development is a fundamental part of each designated mission area, it is within the technology mission area that new and emerging concepts will be nurtured into the programs and missions of tomorrow.

"Continuing to maintain technical superiority is both a national and a Draper Laboratory goal. It is extremely important that the key technologies Draper pursues have application to future national needs. The greatest challenge will be to keep abreast of the timely convergence of new Draper technology with national need. Draper Laboratory has accepted this challenge."

JOHN J. DEYST
DIRECTOR, TECHNOLOGY
PROGRAMS

"The quality of American technology, thanks to the American worker, has enabled us to successfully deal with difficult military conditions and help minimize precious loss of life. We have given our men and women the very best. And they deserve it."

PRESIDENT GEORGE BUSH...
ADDRESS BEFORE A
JOINT SESSION OF THE CONGRESS
ON THE STATE OF THE UNION
JANUARY 29, 1991

T

SPACE SYSTEMS

THE APOLLO PROGRAM WAS DRAPER LABORATORY'S INITIAL MAJOR INVOLVEMENT WITH MANNED SPACE PROGRAMS. THE SPACE SHUTTLE IS THE SECOND, AND DRAPER HAS ESSENTIALLY BECOME THE ON-ORBIT FLIGHT CONTROL AND THE POWERED FLIGHT GUIDANCE DESIGN EXPERTS ON THAT PROGRAM. WE ARE STILL HEAVILY INVOLVED IN THE FLIGHT READINESS AND MISSION SUPPORT ROLES INVOLVING THOSE SUBSYSTEMS AND, IN PARTICULAR, THE ON-ORBIT DEPLOYMENT-RETRIEVAL DYNAMICS INVOLVING THE FLIGHT CONTROL SYSTEM, THE REMOTE MANIPULATOR, AND PAYLOADS. TECHNOLOGIES DEVELOPED BY DRAPER AND NASA ON THE SPACE SHUTTLE ARE BEING APPLIED TO THE SPACE STATION PROGRAM, PARTICULARLY THE SOFTWARE DEVELOPMENT AND VERIFICATION PROCESSES, ONE OF THE MAJOR DEVELOPMENT SYSTEMS AND PROBLEMS FOR THE SPACE STATION. DRAPER'S UNMANNED SPACE ACTIVITIES DATE BACK TO VERY EARLY ATTITUDE CONTROL SYSTEM DESIGNS FOR SOME OF THE ORIGINAL AGENA DoD VEHICLES AND THE ORBITING ASTRONOMICAL OBSERVATORY FOR NASA'S UNMANNED SYSTEM. THIS WORK EVOLVED TOWARD THE STRATEGIC DEFENSE INITIATIVE DESIGN EFFORTS OF THE SAME TYPE OF ATTITUDE CONTROL SYSTEM. THESE SYSTEMS HAVE A HIGH DEGREE OF PERFORMANCE IN TERMS OF POINTING ACCURACIES AND TRACKING. CURRENTLY, DRAPER IS INVOLVED IN THE SUPPORT OF UNMANNED SYSTEMS IN BOTH COMMERCIAL AND GOVERNMENT PROGRAMS.

ADVANCED SPACE PROGRAMS SUCH AS THE LUNAR MARS MISSION OF THE SPACE EXPLORATION INITIATIVE WILL REQUIRE NATIONAL-LEVEL REVIEW AND APPROVAL TO BE REALIZED. AT DRAPER, THESE POTENTIAL FUTURE PROGRAMS HOLD THE SAME INTRIGUE AND CHALLENGE AS DID THE APOLLO PROGRAM 30 YEARS AGO. ALTHOUGH THERE ARE UNIQUE TECHNICAL PROBLEMS TO ADDRESS, THE SAME TYPE OF TECHNOLOGY APPLIES. DRAPER IS ACTIVELY WORKING ON THESE PROBLEMS WITH ITS OWN FUNDS THROUGH CORPORATE-SPONSORED RESEARCH. DRAPER ENGINEERS ARE WORKING DIRECTLY WITH THE NASA TASK FORCE TO DEFINE THE EARLY PHASES OF THE LUNAR MARS PROGRAM. THIS EFFORT WILL RANGE FROM UNMANNED PRECURSOR MISSIONS, THROUGH LUNAR LANDINGS AND BASES, AND EVENTUALLY TO MARS LANDINGS.

10.

"Draper Laboratory continues to build its reputation as a nationally recognized space dynamics design and development organization for manned and unmanned space programs. As of this year, Draper has participated for 30 years in the NASA Manned Space Program. We're still very actively involved in the Space Shuttle and Space Station. Draper's reputation is based on years of experience in overall guidance, navigation, and control system design and supporting sensor, actuator, and data management system design.

"In addition to active involvement in current programs, Draper continues to explore and develop new designs for advanced inertial systems, precision pointing and tracking concepts, and fiber-optic gyro designs in support of advanced space systems. In these future programs, Draper Laboratory's targeted role, again, will be focused on our expertise and technical strengths in guidance, navigation, and control."

NORMAN E. SEARS
DIRECTOR,
SPACE PROGRAMS

"The basic "imperatives" of today's national civil space effort are, therefore, to: sustain our heritage to learn, explore, and discover; maintain our technological competitiveness in global markets; and enhance the quality of life on earth."

REPORT OF THE ADVISORY
COMMITTEE ON THE FUTURE OF THE
U.S. SPACE PROGRAM,
DECEMBER 1990

Cover and inside spreads from Mark Twain's diaries of Adam and Eve, one of a series of limited-edition books published as a holiday promotion.

DESIGN FIRM:

Sibley/Peteet Design,

Dallas, Texas

ART DIRECTORS/

DESIGNERS/

ILLUSTRATORS:

Rex Peteet, Don Sibley

DIECUT SILHOUETTES:

David Beck

TYPOGRAPHERS:

David Beck, Tom Hough

Cover and spreads from EGO, the club's magazine.

DESIGN FIRM: Brainstorm, Atlanta, Georgia

ART DIRECTOR: Ted Fabella

DESIGNER: Matt Strelecki

COPYWRITERS:

Dianna Thorington,

Rich Halten

ILLUSTRATORS: Kevin Irby, P.J. Meacham

PHOTOGRAPHY: Kevin Irby, Pelosi & Chambers

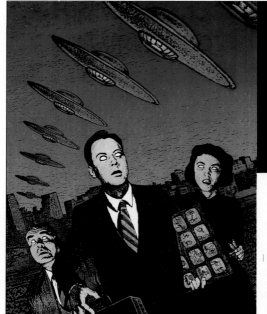

INVASION OF THE ACCOUNT SNATCHERS

Much like another well known universe, the Atlanta Ad Cosmos (or black hole, as some would have it) just keeps expanding exponentially. For every Bozell that explodes in a supernova, new agencies appear out of the chaos, joining the pursuit of a finite amount of clients. At least you recognized the faces of your rivals. But now, intense and relentless life forms are here on a mission. Upstarts from dim spots in the Southern galaxy BY RICH HALTER (Tampa, New Orleans, and—excuse me—Greenville!?) that were presumed too distant, or too backward, to worry about. Quickly rooting themselves into the community, these aliens have begun to possess the minds and hearts of some rather impressive clients. Our clients! But will the invaders have some positive influence on the invadees? These intruders, while three distinct corporate cultures, have one common ILLUSTRATION BY P.J. MEACHAM characteristic: they are true believers in the power of creative. And they mean to use it to get what they want. We can only hope their passion for stellar work will be the catalyst for a great leap in Atlanta's creative evolution. AdWeek's Jim Osterman takes a "We'll see" attitude: "I don't know if they'll raise the creative standards. They're not claiming outrageous things—at least not on the record. All the potential is there, but that's only 25% of it. You've gotta get the clients, then you've got to get the work sold." Here's a look at how each of the three is going about doing just that. <Continued on following page>

IMPACT PLAYERS

By Mimi Bean

The Portfolio Center in Atlanta exists to train creatives in a professional environment. Students come to build a portfolio, make contacts and get a job. There are no books (except in the library), no papers (except briefs), and no tests (except critical review of everything every student produces). In the 12 years since it began, hundreds of creative professionals have taught there, thousands of would-be's have enrolled, and 493 students have graduated. The school can be profiled in terms of any of these, but we interviewed five graduates – one from each program – who have little in common except their PC experience. And the fact that they don't want your job. They want better.

Michael Wilde (PC '87 art direction) always knew what he wanted. "Chiat/Day. I knew they didn't take people without experience, so I lobbied to get on at Benito (now Fahlgren Swink/Benito) in Tampa. I wanted a small agency where I'd have responsibility and experience – and at Benito, I was doing TV my first month. I got all the small stuff, sure, but I tried to make every job the best I could do. I think anything can be bookable. The One Show, and created jobs to build up my portfolio. Two years later, it was time to move, and Chiat/Day (now Goldberg Moser O'Neill) brought me to San Francisco."

Wilde's background was extensively, strictly art, "but the energy – the business side of the creative energy – was missing. Advertising provides that." His current assignments include Celestial Seasonings herb teas and American Dream, a frozen dessert. He just finished work for Dreyer's ice cream and is now preparing a big campaign for Dell Computers.

Raymond McKinney (PC '89 copywriting) took a shorter path to big-time agency work. He was hired by the Martin Agency, after showing his student book and self-promo. In 19 months at Martin, his work has been in the New York Art Director's Club Annual and won a Silver in the British D&AD.

The Martin Agency was McKinney's first choice; he originally sent in his book simply to establish a relationship. He attributes success to "extreme luck." "Also, I work hard to make up for a lack of talent. I put in enormously long hours and feel an everpresent need to keep up. My partner (AD Jelly Helm, also a PC grad) is one of the most talented people I've ever met – and still, every time we get an assignment we feel the fear. Then we eat a lot of ice cream and stare at each other, thinking, 'We got lucky before. We got lucky before.'"

McKinney enrolled in the PC with undergraduate double majors in English and economics ("Mom insisted on something solid to fall back on") and 18 months in law school. "The pressure," he says, "is about the same."

The PC can be compared in other ways to upscale graduate school. Tuition is about 75% of the cost of two years of graduate study at Yale. From observation, PC students' dedication is comparable. So are their parties. So is their 'old boy' network.

"The school is a meeting ground for talent," affirms **Lindy Burnett** (PC '87, illustration), who freelances from the studio at her home in Atlanta. "It's a nucleus – a basis for professional relationships. When my class graduated in '87, we all spread out like spiders to the four corners of the world (except me) clutching each other's business cards. Those cards were the very founda-

tion of my business."

Unlike most PC students, Lindy had a husband, two children, and a mortgage. "I had to support the family because my husband was in law school. As a student, I took every freelance job that came in. You become versatile because, by golly, that's just the way life has to be. Plain old grit – that's my whole thing."

Burnett's family is from Georgia, and she intends to stay in Atlanta. She recently signed with a national rep and is moving into larger markets. She just won the National Dimensional Illustrators Award, and is about to do her first children's book. "The publisher sent me the manuscript and said I can do whatever I want. My latest ad campaign, for Kraft Spreadery, is real 'edge' – wacky, but fun. I like that. Thought is vital, but snobbery – intellectualism for its own sake or the quest to confuse – I vehemently oppose. The

world is confusing enough."

Chas (PC '85 photography) agrees. "I've gotten past the point where everything has to be art. When you get out of school, you think, 'I'll just do beautiful stuff and everyone will want it,' but you grow out of that. Now when I get an assignment I don't judge it – I figure the agency has done that. My job is to understand what they want photographically, and then provide it. If they want my creative input, I provide that, too."

He is pleased that "We're loosening up a lot. Art directors aren't as scared of funky stuff as they used to be. They're more accepting of creative." He cites for example his work on Samsonite Furniture for Cole Henderson Drake, just named AdWeek Editor's Choice of the best 1990 business-to-business ads, and four ads, just finished, to run in Vogue.

Chas' photography career started at the PC in '82. "I went to learn technique. I was serious about it, thrilled to be working there. They gave me a key and I did nothing else – nights, weekends – for 18 months." After graduation, took a job assisting in New York, and 2-1/2 years later returned to Atlanta to start a studio with partner, Jody Gaddy.

In his spare time, Chas is a serious gardener. Burnett likes to "teach pottery at a boys' camp for two weeks each summer. It's good therapy." McKinney, however, admits, "I freelance. Advertising is my job and my hobby. I think it's addictive." He says that "the most important thing I've learned is if you're doing radio in New York and find yourself in a men's room next to Bobby Knight, don't be

afraid to ask for his autograph. And don't take criticism personally. No, seriously, the PC lets you build the callouses up, so rejection isn't so bad."

Donna Aldridge (PC '91, graphic design) agrees. "You only learn to defend your work by being shot down. More important, work that's not based on a concept is not defensible. 'It looks good' isn't good enough." Donna graduated in March and is now on the 7-member staff of the Promotional Department at Tracy Locke, Dallas. She came to the Portfolio Center with a BFA in graphic design and "a book that wasn't good enough to get me advanced placement."

Aldridge credits the PC with "teaching me how to communicate with other creatives – illustrators, for example. In the field, you need to know it all." Her seemingly seamless transition from school to agency work is becoming a bankable expectation of a PC graduate. But Aldridge may take some advice from Wilde, who says that "when you're fresh out of school, you think of yourself as a designer or a copywriter. After a few years, you think of yourself as an advertiser – and then you concentrate on the client and what you can do to sell the product. But you're still a student, no matter how old you are. You learn each and every day."

Mimi Bean, an Emmy-winning producer and former magazine editor, once made up Suzanne Sommers' feet for the Donny and Marie Show and is now a tireless copywriting student at the Portfolio Center in Atlanta.

Cover and spreads from
1991 annual report.

DESIGN FIRM:

Fitch RichardsonSmith,

Boston, Massachusetts

ART DIRECTOR/

DESIGNER: David Warren

PHOTOGRAPHER:

Sal Graceffa

Fold-out insert from

capabilities brochure.

DESIGN FIRM:

Zender+Associates, Inc.,

Cincinnati, Ohio

ART DIRECTOR/

DESIGNER: Mike Zender

PHOTOGRAPHERS:

Dave Steinbrunner,

Mike Zender

PRINTER:

The Hennegan Company

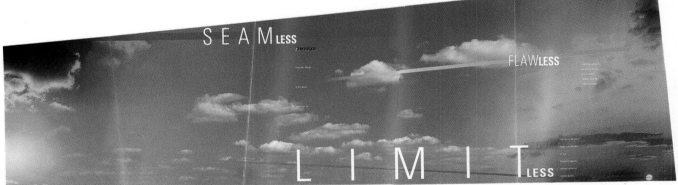

Cover and spreads from 1991 annual report.

DESIGN FIRM:

Zender+Associates, Inc., Cincinnati, Ohio

ART DIRECTORS:

Molly Schoenhoff, Mike Zender

DESIGNER:

Molly Schoenhoff

PHOTOGRAPHERS:

Dave Steinbrunner, Todd Joyce

PRINTER:

Central Printing Company

Bus poster promoting

classical music station.

DESIGN FIRM:

Paul Davis Studio,

New York, New York

ART DIRECTOR/

ILLUSTRATOR: Paul Davis

ART DIRECTORS
CREATIVE DIRECTORS
DESIGN DIRECTORS
DESIGNERS

ARTISTS/COPYWRITERS/ ILLUSTRATORS/LETTERERS/ PHOTOGRAPHERS/ PRINTERS/TYPESETTERS